*Anecdotes*

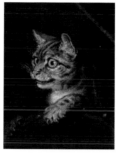

*of William Hogarth*

# Anecdotes of William Hogarth

William Hogarth

introduced by
Martin Myrone

J. Paul Getty Museum, Los Angeles

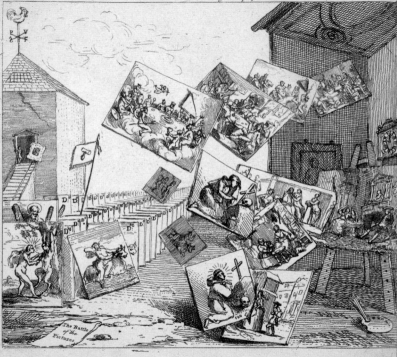

*The Battle of the Pictures, 1745*
*This image of Hogarth's paintings fighting with assorted Old Masters was*
*issued by him as a bidder's ticket to an auction of his works*

# CONTENTS

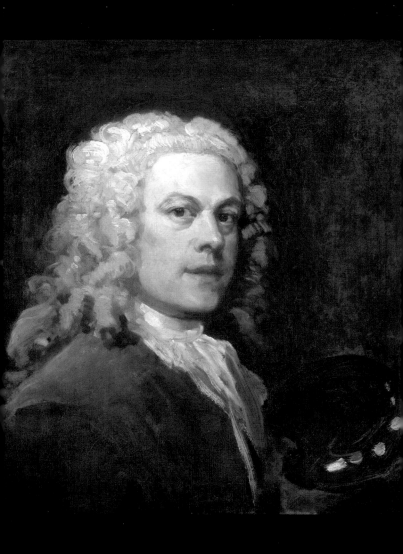

# INTRODUCTION

## MARTIN MYRONE

### 'SHIFTING FOR MYSELF': HOGARTH'S PROGRESS

'There is some', observed Hogarth, in amongst the mass
of reflections and notes drawn up late in life, from which
his editor John Ireland extracted the autobiography re-
published here. 'There is something', he meant to write,
for those notes are rough drafts, 'so bewitching in these
arts that in spite of poverty there will always be too many
Poets and Painters'. On the same sheet Hogarth calcu-
lated that there could never be 'More than three History
painters or as many statuarys' that 'can be supported in
this country', and that 'if we have three lanskip painters
they barely live'. He was writing from experience: 'in my
time I have known three most excellent superior paint
ers, all of [them] extremely industrious', yet all of whom
struggled, and 'two of them dyed in great poverty'.
Penned in the last years of his life, these were the words

*Opposite: Self-portrait, c.1735 (unfinished)*

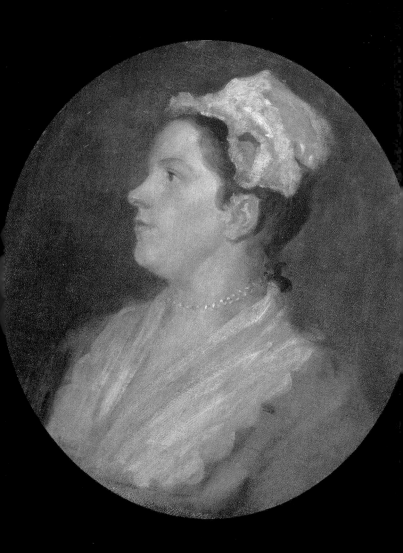

of a painter and engraver who had achieved significant commercial and professional success, succeeding eventually even to the role of Sergeant-painter to the King (a role he had long coveted when it had belonged to his father-in-law James Thornhill and then in succession to his considerably less talented son John Thornhill). But they were the words, too, of someone who had been bruised and beaten by professional struggles, who had seen his printed designs pirated and others profiting by them, who had been publicly abused by fellow artists and sniped at by critics and driven to an embittered isolation in his final years. They reveal someone who had always been acutely aware of the vulnerabilities of the professional artist, at least any artist who had to make his living on the open marketplace with little in the way of personal favour or social status to assist him. The raw economics of the artist's life are here exposed explicitly, precarity pinpointed as the condition for any creative existence in the context of a selfish and corrupted age.

These comments come from a manuscript published in its original form only in the late 1960s, carefully edited by Michael Kitson under the title 'Apology for Painters'. The autobiographical elements of the same disorderly

*Opposite: Ann Hogarth, c. 1740. The artist's two younger sisters, Mary and Ann, sold ready-made clothing from the Old Frock Shop in the City of London*

body of material, extracted by Ireland and held mainly by the British Library (a few sheets found their way elsewhere), had already been published in 1955 by Joseph Burke as an appendix to his scholarly edition of Hogarth's theoretical work of 1753, *The Analysis of Beauty*. Together with the drafts of the *Analysis*, also in the British Library, all these manuscript materials had originally been owned and used by John Ireland. Although by no means a cohesive, or even especially coherent, body of materials, they together constitute an extended reflection by the artist on the nature of artistic work in the jostling, competitive, fraught but also exciting and rapidly expanding eighteenth-century world of art that Hogarth had experienced over the previous five decades. If these themes are at other times expressed in generalised or abstracted form, and if Hogarth repeatedly turns to more generic reflection about the nature of art and the powers of observation, it is with his own life experience that these issues are brought down to earth, made concrete and most comprehensible. It is this reflective context that is crucial to our interpretation of Hogarth's autobiography, even if it is lost somewhat when Ireland tidied up the autobiographical notes into a generally more conventional life narrative.

Ireland, nonetheless, did a great service to readers by organising Hogarth's notes as he did. The life story set

out by Hogarth himself has been widely in use since it first appeared in print at the end of the eighteenth century. Ireland was an admirer of Hogarth, acquiring from Mrs. Mary Lewis of Chelsea, executrix of Hogarth's widow's will, a collection of prints, engraved copperplates and the bundled manuscripts. His *Hogarth Illustrated* (1791; second edition 1793; third 1806) sketched out the artist's career and provided extensive commentary on his prints. *A Supplement to Hogarth Illustrated* (1798), a third volume of *Hogarth Illustrated*, comprised the manuscript materials, including the autobiographical notes, providing a foundation for modern scholarship on the artist. The *Supplement* appeared in a second edition in 1804, and the autobiography appeared in J. B. Nichols' *Anecdotes of William Hogarth written by himself; With essays on his life and genius, and criticisms on his works, selected from Walpole, Gilpin, J. Ireland, Lamb, Phillips, and others* (1833) which provides the materials for a 'reception history' of an artist by then being installed as a English Old Master, even a 'national treasure' (the famous self-portrait with his pug, Trump, had been purchased by the nascent National Gallery in 1824). There were various republications and quotations over the next century, until the editions based on the manuscripts mentioned above, and the useful modern printing of Nichols' *Anecdotes* (1970) with an introduction by Ronald Lightbown.

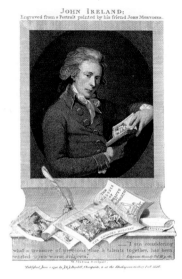

*John Ireland, reading his book on Hogarth and with Hogarth's works on the plinth below; frontispiece to* Hogarth Illustrated, *in a print by W. Skelton after John Hamilton Mortimer, 1791*

Ireland was a professional biographer who knew his craft well. As a friend of Thomas Gainsborough and John Hamilton Mortimer, he also knew artists and the art world. He was, as Kitson notes, 'a careful editor' of the manuscripts left by the painter, and he did 'his best to reproduce Hogarth's meaning'. Readers have found in Hogarth's own words affirmations of the pugaciousness, critical intelligence and common sense that are

otherwise to be extrapolated from the sometimes ab-
struse theoretical reflection of the *Analysis* or encoded
in his printed and painted images. But the raw text of
Hogarth's original was rendered 'bland' (Kitson's term)
by Ireland, at the same time as being made more lucid.

Hogarth was born, he noted himself, and Ireland
relates, 'in the City of London' on 10 November 1697,
and he was baptised on 28 November in that same year.
Hogarth had in fact ingeniously omitted the dates from
the manuscript, so Ireland supplied them. Ireland fol-
lowed Hogarth, though, in providing the key statement
about his family background, put originally in the third
person: 'His Fathers Pen like that of many other authors
was incapable of more than putting him in a way to shift
for himself'. Hogarth's father, Richard Hogarth, was an
author and schoolmaster, who had indeed struggled to
make ends meet from his writing and had, moreover,
been undone and imprisoned for debt in 1712 after the
failure of a coffee-house whose habitués were obliged
to speak Latin. If that later project seems to us a self-
evidently ill-advised commercial venture, Hogarth drew
attention instead to the 'cruel treatment he met with
from Bookseller and Printers particularly in the affairs
of a lattin Dictionary' which never appeared before his
untimely death in 1718. Hogarth was indeed left 'shifting
for myself', without the option of a university education

*Detail from a piece of silver thought to have been engraved by Hogarth:
The Walpole Salver, 1728-29, by Paul de Lamerie*

or professional career that a more successful schoolmas-
ter's son might have anticipated. He was apprenticed
instead to a silver engraver. In the muddled manuscript
notes he returns several times to the point, aged twenty
or twenty-three or twenty-four (all these ages are stated),
that he turned instead to more inventive art, to an in-
novative form of portrait painting with 'figures from 10
to 15 inches high', to 'the grand stile of history paint-
ing' and the 'Modern moral subject'. He accounts for his
time to that date as 'lost … in business that was rather
detrimentall to the arts of Painting and Engraving'.

Although Hogarth does not present it in these terms, he was arguably fortunate to have developed such aspirations at a moment of commercial opportunity in Britain. Without the formal hierarchies of the continental academic system, but without, too, much in the way of patronage from monarchy, state or church, artists in the burgeoning metropolis of London were finding novel ways to make money from art. Political stability, the (relative) lack of war, liberty of the press and the proliferation of satire and criticism, together with the rapid expansion of middle-class audiences and the market for images, all conspired to create a situation that Hogarth and others were able to exploit in several ways: with new forms of portrait painting that articulated the more modest, good-humoured values of the emerging social world; with narrative and theatrical pictures that provided entertainment and a certain degree of moral education; and, crucially, with the engraved prints reproducing such pictures which could profitably disseminate an artist's ideas and identity at a speed and across a social spectrum that was unprecedented.

In the summary words of Ronald Paulson, the scholar whose biography and catalogue of prints are foundation stones for present-day Hogarth scholarship, 'The burden of the autobiography is that he was self-taught, a tradesman, a patriotic Englishman: he was a champion

*The Graham Children, 1742.*
*This group portrait shows the*
*family of Daniel Graham,*
*apothecary to George I and*
*George II*

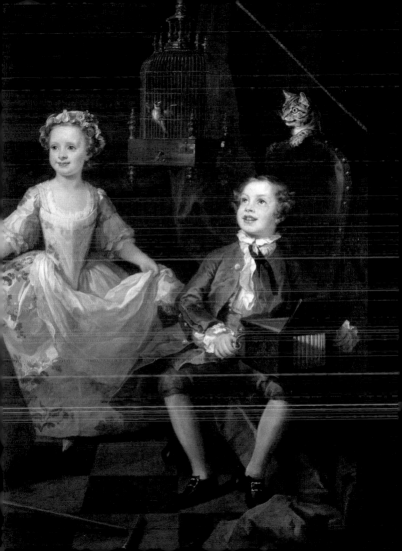

of liberty and the individual against printsellers, pirates, connoisseurs, and political extremists'. Hogarth opposes what we might label 'book learning' and insists instead upon native talents and the innate powers of observation whose possession might be an accident of birth but whose consummation depended upon 'Encouragement and opportunity'. These themes are apparent in Ireland's rendering of the autobiography, but are even more vivid in the theoretical digressions and reflections upon the art world that punctuate the original manuscript so untidily. Generally smoothed out to facilitate the presentation of a more linear life story, Hogarth's text is made by Ireland to conform – to a point – to the emerging norms of the writing of artists' lives. These were arguably less sensitive to the social and economic contingencies that run through Hogarth's commentary on his emergence as an artist. He rejects the idea that 'a man must be born a Painter', as if genius were a mere accident. The artist is, in his account, socially produced, with whatever innate talent he may be equipped with sharpened, blunted or misdirected according to circumstances.

Thus it is that Hogarth's narrative, even in Ireland's rendering, may seem to the modern reader rather lopsided and errant in some regards. It is a 'progress', full of ups and more downs, leading ultimately to disappointment rather than fulfilment. But as the literary scholar Karen

Junod notes, the texts 'focused on Hogarth's professional achievements as a painter and engraver, but failed to provide what most eighteenth-century biographers were keen to offer: personal anecdotes about the painter's life'. He spends longer than we might expect ruminating upon his background and youth and is surprisingly frank about the wasted years of his youth before he ventured out as a painter and designer. He is unexpectedly direct about his technical limitations as an engraver and his shortcomings as a painter of portraits. He gives a great deal of space and energy to his frustrations with print-sellers, picture-dealers and publishers, and especially with the proposals for a formal art academy from among fellow-artists which seemed to him to risk putting British art on an entirely wrong footing, driven by pretensions to excel and theoretical notions rather than an engagement with life as it is lived and the production of paintings that spoke to the experience of the present. He takes time to take a swipe at the now almost forgotten French portrait painter Jean-Baptiste Vanloo, and dwells upon the ill-fated production of a history painting, *Sigismunda* (1759, Tate) which brought him public embarrassment at the end of his life. His history paintings for St Bartholomew's Hospital are given prominence, and the argument with the urbane Scottish portrait painter Allan Ramsay set out in full, with Hogarth's pride in his triumphant portrait

1735 Rec.d Apr.t 8 29 Tho Grimston Esq.r

Half a Guinea being the first Payment for Nine Prints, 8 of Which
Represent a Rakes Progress & the 9.th a Fair, Which I Promise to
Deliver when finish'd d... on Receiving one Guinea more, the
Print of the Fair being Deliver'd at the time of Subscribing.
N.B. the Rakes alone will be two Guineas after the time of Subscribing.

W.m Hogarth

The Laughing Audience, 1733, used as a subscription ticket for the series of
engravings, A Rake's Progress, and for the print of Southwark Fair

of Captain Coram a centrepiece of the narrative. Yet the modern moral series – A Harlot's Progress, A Rake's Progress and Marriage A-la-Mode, which are now emphatically considered his central achievement as an artist and his major contribution to Western art history – are curiously de-emphasised in the autobiography (the commentaries on individual prints provides some degree of compensation, but not a great deal). Hogarth the social critic, the observer of London life, the scathing chronicler of prostitutes and low-life types and the corrupt in high-life, is scarcely to be distinguished in the account of the painter as a necessarily improvising observer of nature, driven to innovate by financial necessity and personal shortcomings, continually aspiring to paint history and be recognised as an authentic talent. In these respects, Hogarth may appear to be an untrustworthy witness to his own capabilities. But his insistence on struggle and failure, and his emphasis on the material influence of professional disputes and commercial realities, remain refreshingly direct and cut through much of the deception and disingenuity that emerged as stock features of artistic biography in the Romantic era. There are, without doubt, pessimism and disappointment in play when Hogarth wrote these words, which may be distracting. But he also demonstrates an unusually sharp understanding of the emerging realities of the modern

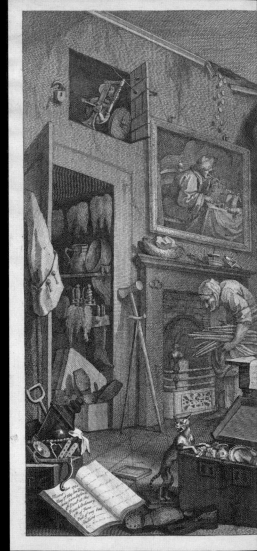

*A Rake's Progress,*
*Plate 1, 1735.*
*Tom Rakewell comes*
*into his inheritance*

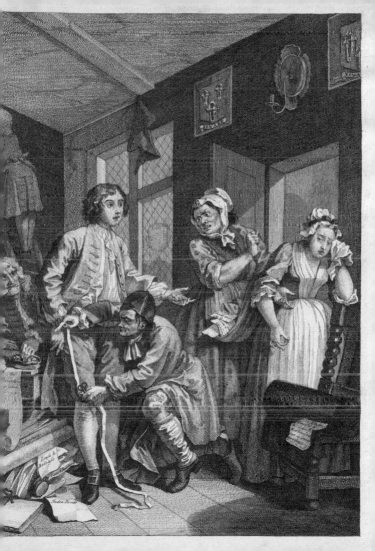

art world, both as a place of brutal commercial competition and professional rivalry, and an environment where the 'bewitching' nature of art was renewed sufficiently to inspire the kind of resilience, innovation and passion that are so apparent in Hogarth's life and art – and in his autobiographical musings.

SOME FURTHER READING

David Bindman, *William Hogarth*, London, 1981

Joseph Burke, ed., *William Hogarth: The Analysis of Beauty; With the Rejected Passages from the Manuscript Drafts and Autobiographical Notes*, Oxford, 1955

Mark Hallett and Christine Riding, eds., *Hogarth*, exhibition catalogue, Tate Britain, London, 2006

Karen Junod, '*Writing the lives of painters': Biography and artistic identity in Britain, 1760-1810*, Oxford, 2011

Michael Kitson, 'Hogarth's "Apology for Painters"', *The Walpole Society*, vol. 41 (1966), pp. 46–111

Ronald Paulson, *Hogarth*, 3 vols, New Brunswick and New Jersey, 1991-93

Ronald Paulson, ed., *William Hogarth: The Analysis of Beauty*, New Haven and London, 1997

Marcia Pointon, *William Hogarth's* Sigismunda *in focus*, London, 2000

# ANECDOTES
# OF WILLIAM
# HOGARTH

## BY HIMSELF

### EDITED BY
### JOHN IRELAND

*The texts reproduced here are taken from eighteenth-century publications, and we have tried to stay close to the original wording, punctuation and layout. Some vocabulary and turns of phrase may be unfamiliar to readers today, but the price of over-modernisation is to make the texts less authentic, and less illuminating as a window onto the past. This is especially true for the rough and ready writings of William Hogarth, even as presented by their faithful contemporary editor, John Ireland. Ireland wanted to help the reader by turning the painter's crude jottings into some kind of continuous prose, without altogether losing the flavour of Hogarth's sturdy character, and as far as possible we have respected his transcription. The chapter summaries are by Ireland, as are his occasional interventions in the text (shown here in italics), and some of the notes (as indicated).*

# CHAPTER ONE

*Hogarth's own account of his birth and early education;*
*reasons for his being apprenticed to a silver-plate engraver;*
*with which employment becoming disgusted, he commences*
*an engraver on copper; his method of study; the fate*
*of the first print he published*

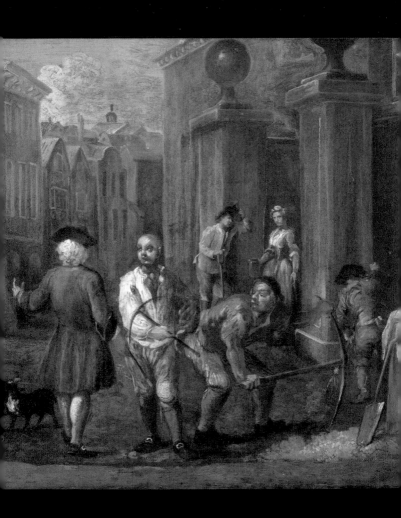

I was born in the City of London, on the 10th day of November 1697, and baptized the 28th of the same month. My father's pen, like that of many other authors, did not enable him to do more than put me in a way of shifting for myself. As I had naturally a good eye, and a fondness for drawing, *shows* of all sorts gave me uncommon pleasure when an infant; and mimicry, common to all children, was remarkable in me. An early access to a neighbouring painter, drew my attention from play; and I was, at every possible opportunity, employed in making drawings. I picked up an acquaintance of the same turn, and soon learnt to draw the alphabet with great correctness. My exercises when at school were more remarkable for the ornaments which adorned them than for the exercise itself. In the former I soon found that blockheads with better memories could much surpass me; but for the latter, I was particularly distinguished.

Besides the natural turn I had for drawing rather than learning languages, I had before my eyes the

*Opposite: Attributed to Hogarth, Sign for a Paviour, c. 1725. According to his pupil Philip Dawes, Hogarth considered the work of sign painters as 'specimens of genius emanating from a school, which he used emphatically to observe, was truly English'.*

precarious situation of men of classical education. I saw the difficulties under which my father laboured, and the many inconveniences he endured, from his dependance being chiefly on his pen, and the cruel treatment he met with from booksellers and printers, particularly in the affair of a Latin Dictionary,* the compiling of which had been a work of some years. It was deposited, in confidence, in the hands of a certain printer, and, during the time it was left, letters of approbation were received from the greatest scholars in England, Scotland, and Ireland. But these flattering testimonies from his acquaintance (who, as appears from their letters, which I have still by me, were of the first class), produced no profit to the author. It was therefore very conformable to my own wishes that I was taken from school, and served a long apprenticeship to a silver-plate engraver.

I soon found this business in every respect too limited. The paintings of St Paul's Cathedral and

* The Dictionary here alluded to, Mrs. Lewis, of Chiswick, presented to me. It is a thick quarto, containing an early edition of Littleton's Dictionary, and also Robertson's Phrases; with numerous corrections to each, and about 400 pages of manuscript close written. On the marginal leaf is inscribed, in Hogarth's hand-writing: "The manuscript part of this Dictionary was the work of Mr. Richard Hogarth."—Note by J. Ireland

Greenwich Hospital, which were at that time going on, ran in my head; and I determined that silver-plate engraving should be followed no longer than necessity obliged me to it. Engraving on copper was, at twenty years of age, my utmost ambition. To attain this it was necessary that I should learn to draw objects something like nature, instead of the monsters of heraldry, and the common methods of study were much too tedious for one who loved his pleasure, and came so late to it; for the time necessary to learn in the usual mode, would leave me none to spare for the ordinary enjoyments of life. This led me to considering whether a shorter road than that usually travelled was not to be found. The early part of my life had been employed in a business rather detrimental than advantageous to those branches of the art which I wished to pursue, and have since professed. I had learned, by practice, to copy with tolerable exactness in the usual way; but it occurred to me that there were many disadvantages attending this method of study, as having faulty originals, &c. and even when the pictures or prints to be imitated were by the best masters, it was little more than pouring water out of one vessel into another. Drawing in an academy, though it should be after the life, will not make the student an artist; for as the eye is often taken from the original, to draw a bit at a time, it

is possible he may know no more of what he has been copying, when his work is finished, than he did before it was begun. There may be, and I believe are, some who, like the engrossers of deeds, copy every line without remembering a word; and if the deed should be in law Latin, or old French, probably without understanding a word of their original. Happy is it for them; for to retain would be indeed dreadful. A dull transcriber, who in copying Milton's "Paradise Lost" hath not omitted a line, has almost as much right to be compared to Milton, as an exact copier of a fine picture by Rubens hath to be compared to Rubens. In both cases the hand is employed about minute parts, but the mind scarcely ever embraces the whole. Besides this, there is an essential difference between the man who transcribes the deed, and he who copies the figure; for though what is written may be line for line the same with the original, it is not probable that this will often be the case with the copied figure; frequently far from it. Yet the performer will be much more likely to retain a recollection of his own imperfect work than of the original from which he took it.

More reasons, not necessary to enumerate, struck me as strong objections to this practice, and led me to wish that I could find the shorter path,—fix forms and characters in my mind, and, instead of *copying* the

lines, try to read the language, and if possible find the grammar of the art, by bringing into one focus the various observations I had made, and then trying by my power on the canvas, how far my plan enabled me to combine and apply them to practice.

For this purpose, I considered what various ways, and to what different purposes, the memory might be applied; and fell upon one which I found most suitable to my situation and idle disposition.

Laying it down first as an axiom, that he who could by any means acquire and retain in his memory, perfect ideas of the subjects he meant to draw, would have as clear a knowledge of the figure, as a man who can write freely hath of the twenty-four letters of the alphabet, and their infinite combinations (each of these being composed of lines), and would consequently be an accurate designer. This I thought my only chance for eminence, as I found that the beauty and delicacy of the stroke in engraving was not to be learnt without much practice and demanded a larger portion of patience than I felt myself disposed to exercise. Added to this, I saw little probability of acquiring the full command of the graver, in a sufficient degree to distinguish myself in that walk; nor was I at twenty years of age, much disposed to enter on so barren and unprofitable a study, as that of merely making fine

lines. I thought it still more unlikely, that by pursuing the common method, and copying *old* drawings, I could ever attain the power of making *new* designs, which was my first and greatest ambition. I therefore endeavoured to habituate myself to the exercise of a sort of technical memory; and by repeating in my own mind, the parts of which objects were composed, I could by degrees combine and put them down with my pencil. Thus, with all the drawbacks which resulted from the circumstances I have mentioned, I had one material advantage over my competitors, *viz.* the early habit I thus acquired of retaining in my mind's eye, without coldly copying it on the spot, whatever I intended to imitate.* Sometimes, but too seldom, I took the life, for correcting the parts I had not perfectly enough remembered, and then I transferred them to my compositions.

My pleasures and my studies thus going hand in

---

* Though averse, as he himself expresses it, to *coldly copying on the spot* any objects that struck him, it was usual with him when he saw a singular character, either in the street or elsewhere, to pencil the leading features, and prominent markings upon his nail, and when he came home, to copy the sketch on paper, and afterwards introduce it in a print. Several of these sketches I have seen, and in them may be traced the first thoughts for many of the characters which he afterwards introduced in his works.—Note by John Ireland.

hand, the most striking objects that presented themselves, either comic or tragic, made the strongest impression on my mind; but had I not sedulously practised what I had thus acquired, I should very soon have lost the power of performing it.

Instead of burdening the memory with musty rules, or tiring the eyes with copying dry and damaged pictures, I have ever found studying from nature the shortest and safest way of attaining knowledge in my art.* By adopting this method, I found a redundancy of matter continually occurring. A choice of composition was the next thing to be considered, and my constitutional idleness naturally led me to the use of such materials as I had previously collected; and to this I was further induced by thinking, that if properly combined, they might be made the most useful to society in painting, although similar subjects had often failed in writing and preaching.

To return to my narrative,—the instant I became master of my own time, I determined to qualify

---

* As this was the doctrine I preached as well as practised, an arch brother of the pencil once gave it this turn; that the only way to draw well, was not to draw at all; and on the same principle, he supposed, that if I wrote an essay on the art of swimming, I should prohibit my pupil from going into the water, until he had learnt.

myself for engraving on copper. In this I readily got employment; and frontispieces to books, such as prints to Hudibras, in twelves, &c. soon brought me into the way. But the tribe of booksellers remained as my father had left them, when he died about five years before this time, which was of an illness occasioned partly by the treatment he met with from this set of people, and partly by disappointment from great men's promises; so that I doubly felt this usage, which put me upon publishing on my own account. But here again I had to encounter a monopoly of printsellers, equally mean, and destructive to the ingenious; for the first plate I published, called *The Taste of the Town* in which the reigning follies were lashed, had no sooner begun to take a run, than I found copies of it in the print-shops, vending at half-price, while the original prints were returned to me again; and I was thus obliged to sell the plate for whatever these pirates pleased to give me, as there was no place of sale but at their shops.

*Opposite: The Taste of the Town, 1724. The banner shows a group of English noblemen entreating an Italian singer to perform in London; she rakes in their money. Crowds go to masquerades and commedia dell' arte while a waste paper hawker trundles a barrow full of the works of Shakespeare, Dryden and others. In the background three virtuosi admire Lord Burlington's Italianate gateway, labelled 'Academy of Arts'*

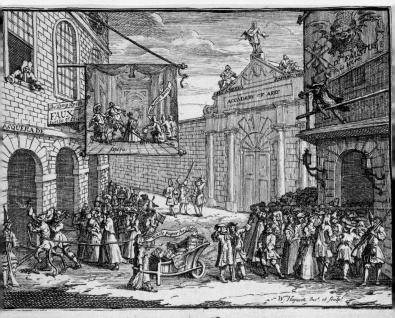

Would new dumb *Faustus*, to reform the Age,
Conjure up *Shakespear's* or *Ben Johnson's Ghost*,
They'd blush for shame, to see the *English Stage*
Debauch'd by fool'ries, at so great a cost.

What would their *Manes* say? should they behold
*Monsters* and *Masquerades*, where usefull *Plays*
Adorn'd the fruitfull *Theatre* of old,
And *Rival Wits* contended for the *Bays*.

Price: Shilling. 1724

Owing to this and other circumstances, by engraving, until I was near thirty, I could do little more than maintain myself; but even then I was a punctual paymaster.

# CHAPTER TWO

*Marries: paints small Conversations, which subjects he quits for familiar prints; attempts History; but finding it not encouraged in England, returns to engraving from his own designs. Occasionally takes portraits large as life, for which he incurs much abuse. To prove his powers and vindicate his fame, paints the admirable portrait of Captain Coram, and presents it to the Foundling Hospital*

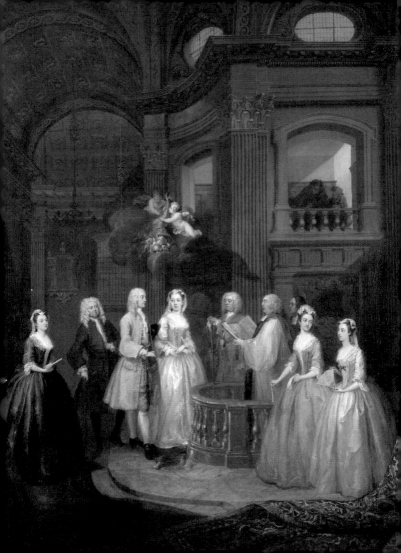

I then married, and commenced painter of small Conversation pieces, from twelve to fifteen inches high. This having novelty, succeeded for a few years. But though it gave somewhat more scope to the fancy, was still but a less kind of drudgery; and as I could not bring myself to act like some of my brethren, and make it a sort of a manufactory, to be carried on by the help of background and drapery painters, it was not sufficiently profitable to pay the expenses my family required. I therefore turned my thoughts to a still more novel mode, *viz.* painting and engraving modern moral subjects, a field not broken up in any country or any age.

The reasons which induced me to adopt this mode of designing were, that I thought both writers and painters had, in the historical style, totally overlooked that intermediate species of subjects, which may be placed between the sublime and grotesque; I therefore wished to compose pictures on canvas, similar to representations on the stage; and further hope that they will be tried by the same test, and criticised by the same criterion. Let it be observed, that I mean to speak only of those scenes where the human species are actors, and these I think have not often been

*Opposite: The Wedding of Stephen Beckingham and Mary Cox, 1729. One of Hogarth's first Conversation pieces*

delineated in a way of which they are worthy and capable. In these compositions, those subjects that will both entertain and improve the mind, bid fair to be of the greatest public utility, and must therefore be entitled to rank in the highest class. If the execution is difficult (though that is but a secondary merit), the author has claim to a higher degree of praise. If this be admitted, comedy, in painting as well as writing, ought to be allotted the first place, as most capable of all these perfections, though *the sublime*, as it is called, has been opposed to it. Ocular demonstration will carry more conviction to the mind of a sensible man, than all he would find in a thousand volumes; and this has been attempted in the prints I have composed. Let the decision be left to every unprejudiced eye; let the figures in either pictures or prints be considered as players dressed either for the sublime,—for genteel comedy,* or farce,—for high or low life. I have endeavoured to treat my subjects as a dramatic writer: my picture is my stage, and men and women my players, who by means of certain actions and gestures, are to exhibit *a dumb show*.

* It has been truly observed that *comedy* exhibits the character of a species,—*farce* of an individual. Of the class in which Hogarth has a right to be placed, there can be little doubt; *he wrote comedies with a pencil.*—Note by J. Ireland.

Before I had done any thing of much consequence in this walk, I entertained some hopes of succeeding in what the puffers in books call *the great style of History painting*; so that without having had a stroke of this *grand* business before, I quitted small portraits and familiar conversations, and, with a smile at my own temerity, commenced history painter, and on a great staircase at St Bartholomew's Hospital, painted two Scripture stories, the *Pool of Bethesda* and the *Good Samaritan*, with figures seven feet high. These I presented to the Charity,[1] and thought they might serve as a specimen to shew that, were there an inclination in England for encouraging historical pictures, such a first essay might prove the painting them more easily attainable than is generally imagined. But as religion, the great promoter of this style in other countries, rejected it in England, I was unwilling to sink into a *portrait manufacturer*; and, still ambitious of being singular, dropped all expectations of advantage from that source, and returned to the pursuit of my former dealings with the public at large. This I found was most likely to answer my purpose, provided I could strike the passions, and by small sums from many, by

1. 1736-37. Both paintings still in situ. Hogarth was elected governor of the Hospital in recognition of his gift

the sale of prints, which I could engrave from my own pictures, thus secure my property to myself.

In pursuing my studies, I made all possible use of the technical memory which I have before described, by observing and endeavouring to retain in my mind lineally, such objects as best suited my purpose; so that be where I would, while my eyes were open, I was at my studies, and acquiring something useful to my profession. By this means, whatever I saw, whether a remarkable incident, or a trifling subject, became more truly a picture than one that was drawn by a *camera obscura*. And thus the most striking objects, whether of beauty or deformity, were by habit the most easily impressed and retained in my imagination. A redundancy of matter being by this means acquired, it is natural to suppose I introduced it into my works on every occasion that I could.

By this idle way of proceeding I grew so profane as to admire nature beyond the first productions of art, and acknowledged I saw, or fancied, delicacies in the life, so far surpassing the utmost efforts of imitation, that when I drew the comparison in my mind, I could not help uttering blasphemous expressions against the divinity even of Raphael Urbino, Corregio, and Michael Angelo. For this, though my brethren have most unmercifully abused me, I hope to be forgiven. I

confess to have frequently said, that I thought the style of painting which I had adopted, admitting that *my* powers were not equal to doing it justice, might one time or other come into better hands, and be made more entertaining and more useful than the eternal blazonry, and tedious repetition of hackneyed, beaten subjects, either from the Scriptures, or the old ridiculous stories of heathen gods; as neither the religion of one or the other requires promoting among Protestants, as it formerly did in Greece, and at a later period in Rome.

For these and other heretical opinions, as I have before observed, I was deemed vain, and accused of enviously attempting what I was unable to execute.

The chief things that have brought much obloquy on me, are first, the attempting portrait painting; secondly, writing the *Analysis of Beauty*; thirdly, painting the picture of *Sigismunda*; and fourthly, publishing the first print of the *Times*.

In the ensuing pages it shall be my endeavour to vindicate myself from these aspersions, and each of the subjects taken in the order they occurred, shall be occasionally interspersed with some thoughts by the way, on the state of the arts, institution of a Royal Academy, Society of Arts, &c. as being remotely, if not immediately connected with my own pursuits.

Though small whole-lengths, and prints of familiar conversations, were my principal pursuit, yet by those who were partial to me I was sometimes employed to paint portraits as large as life, and for this I was most barbarously abused. My opponents acknowledged, that in the particular branches to which I had devoted my attention, I had some little merit; but as neither history nor portrait were my province, nothing but what they were pleased to term extreme vanity, could induce me to attempt either one or the other; for it would be interfering in that branch of which I had no knowledge, and in which I had therefore no concern.

At this I was rather piqued, and as well as I could, defended my conduct, and explained my motives. Some part of this defence it will be necessary to repeat, and it will also be proper to recollect, that after having had my plates pirated in almost all sizes, I in 1735 applied to Parliament for redress; and obtained it in so liberal a manner, as hath not only answered my own purpose, but made prints a considerable article in the commerce of this country; there being now more business of this kind done here, than in Paris, or any where else, and as well.

The dealers in pictures and prints found their craft in danger, by what they called a new-fangled innovation. Their trade of living and getting fortunes by

the ingenuity of the industrious, has, I know, suffered much by my interference; and, if the detection of this band of public cheats, and oppressors of the rising artists, be a crime, I confess myself most guilty.

To put this matter in a fair point of view, it will be necessary to state the situation of the arts and artists at this period. In doing which I shall probably differ from every other author, as I think the books hitherto written on the subject, have had a tendency to confirm prejudice and error, rather than diffuse information and truth. My notions of painting differ, not only from those who have formed their opinions from books, but from those who have taken them upon trust.

I am therefore under the necessity of submitting to the public what may possibly be deemed peculiar opinions; but without the least hope of bringing over either men whose interests are concerned, or who implicitly rely upon the authority of a tribe of picture dealers, and puny judges, that delight in the marvellous, and determine to admire what they do not understand; but I have hope of succeeding a little with such as dare to think for themselves, and can believe their own eyes. As introductory to the subject, let us

*Overleaf: Sir Andrew Fountaine examining a painting, 1730-35*

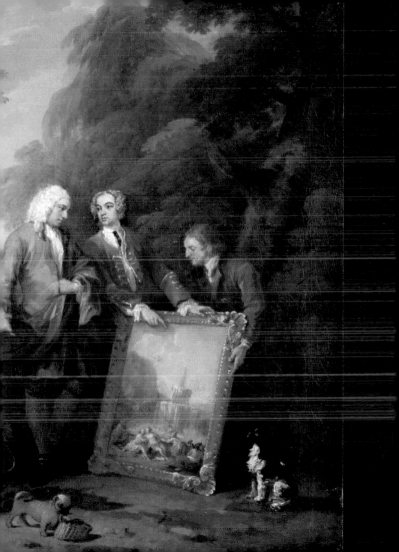

begin with considering that branch of the art which is termed still life; a species of painting which ought to be held in the lowest estimation. Whatever is, or can be perfectly fixed, from the plainest to the most complicated object, from a bottle and glass, to a statue of the human figure, may be denominated still life. Ship and landscape painting ought unquestionably to come into the same class; for, if copied exactly as they chance to appear, the painters have no occasion of judgment; yet, with those who do not consider the few talents necessary, even this tribe sometimes pass for very capital artists.

Well painted, and finely pencilled! are phrases perpetually repeated by coach and sign painters. Merely well painted or pencilled, is chiefly the effect of much practice; and we frequently see that those who are in these particulars very excellent, cannot advance a step further.

As to portrait painting, the chief branch of the art by which a painter can procure himself a tolerable livelihood, and the only one by which a lover of money can get a fortune; a man of very moderate talents may have great success in it, as the artifice and address of a mercer is infinitely more useful than the abilities of a painter. By the manner in which the present race of professors in England conduct it, that also becomes

still life, as much as any of the preceding. Admitting that the artist has no further view than merely copying the figure, this must be admitted to its full extent; for the sitter ought to be still as a statue,—and no one will dispute a statue being as much still life as fruit, flowers, a gallipot, or a broken earthen pan. It must, indeed, be acknowledged, they do not seem ashamed of the title, for their figures are frequently so executed as to be as still as a post. Posture and drapery, as it is called, is usually supplied by a journeyman, who puts a coat, &c. on a wooden figure, like a jointed doll, which they call a layman, and copies it in every fold as it chances to come; and all this is done at so easy a rate, as enables the principal to get more money in a week than a man of the first professional talents can in three months. If they have a sufficient quantity of silks, satins, and velvets to dress their laymen, they may thus carry on a very profitable manufactory, without a ray of genius. There is a living instance, well known to the connoisseurs in this town, of one of the best copiers of pictures, particularly those by Rubens, who is almost an idiot.* Mere correctness, therefore, if in

*Hogarth may possibly allude to Ranelagh Barret, who, I learn from Mr. Walpole, was thus employed; and, being countenanced by Sir Robert Walpole, copied several of his collection, and others

still life, from an apple or a rose, to the face, nay, even the whole figure, if you take it merely as it presents itself, requires only an exact eye and an adroit hand. Their pattern is before them, and much practice, with little study, is usually sufficient to bring them into high vogue. By perpetual attention to this branch only, one should imagine they would attain a certain stroke;—quite the reverse,—for, though the whole business lies in an oval of four inches long, which they have before them, they are obliged to repeat and alter the eyes, mouth, and nose, three or four times, before they can make it what they think right. The little praise due to their productions ought, in most cases, to be given to the drapery man, whose pay is only one part in ten, while the other nine, as well as all the reputation, is engrossed by the master phiz-monger, for a proportion which he may complete in five or six hours; and even this, little as it is, gives him so much importance in his own eyes, that he assumes a consequential air, sets his arms akimbo, and, strutting among the historical artists, cries,—"How we apples swim!"

for the Duke of Devonshire and Dr Mead. He was indefatigable,—executed a vast number of works,—succeeded greatly in copying Rubens,—and died in 1768: his pictures were sold by auction in the December of that year.—Note by John Ireland

For men who drudge in this mechanical part, merely for gain, to commence dealers in pictures is natural. In this also, great advantage may accrue from the labour and ingenuity of others. They stand in the catalogue of painters, and having little to study in their own way, become great connoisseurs; not in the points where real perfection lies, for there they must be deficient, as their ideas have been confined to the oval; but their great inquiry is, how the old masters stand in the public estimation, that they may regulate their prices accordingly, both in buying and selling. You may know these painter-dealers by their constant attendance at auctions. They collect under pretence of a love for the arts; but sell, knowing the reputation they have stamped on the commodity they have once purchased, in the opinion of the ignorant admirer of pictures, drawings, and prints; which thus warranted, almost invariably produce them treble their original purchase-money, and treble their real worth. Unsanctioned by their authority,* and unascertained by tradition, the best preserved and highest finished

*In part of this violent philippic, Hogarth may possibly glance at Sir Joshua Reynolds, whom it has been said, but I think unjustly, he envied. In Sir Joshua's very early pictures there is not much to envy; they gave little promise of the taste and talents which blaze in his later works.—Note by John Ireland

picture (though it should have been painted by Raphael), will not, at a public auction, produce five shillings; while a despicable, damaged, and repaired old canvas, sanctioned by their praise, shall be purchased at any price, and find a place in the noblest collections. All this is very well understood by the dealers, who, on every occasion where their own interest is concerned, are wondrously loquacious in adoring the mysterious beauties! spirited touches! brilliant colours! and the Lord knows what, of these ancient worn-out wonders;—but whoever should dare to hint that (admitting them to be originally painted by Raphael) there is little left to admire in them, would be instantly stigmatized as vilifying the great masters; and to invalidate his judgment, accused of envy and self-conceit. By these misrepresentations, if he has an independent fortune, he only suffers the odium; but if a young man, without any other property than his talents, presumes boldly to give an opinion, he may be undone by his temerity; for the whole herd will unite, and try to hunt him down.

Such is the situation of the arts and artists at this time. Credulity—an implicit confidence in the opinions of others—and not daring to think for themselves, leads the whole town into error, and thus they become the prey of ignorant and designing knaves.

With respect to portrait painting, whatever talents a professor may have, if he is not in fashion, and cannot afford to hire a *drapery-man*, he will not do; but if he is in vogue, and can employ a journeyman, and place a layman in the garret of his manufactory, his fortune is made; and as his two coadjutors are kept in the background, his own fame is established.

If a painter comes from abroad, his being an *exotic* will be much in his favour; and if he has address enough to persuade the public that he had brought a new discovered mode of colouring, and paints his faces all red, all blue, or all purple, he has nothing to do but to hire one of these painted tailors as an assistant, for without him the manufactory cannot go on, and my life for his success.

Vanloo, a French portrait painter, being told that the English were to be cajoled by any one who had a sufficient portion of assurance, came to this country,* set his trumpeters to work, and by the assistance of puffing, monopolized all the people of fashion in the kingdom. Down went at once —*,—*,—*, *, —*,—&c &c. &c. painters who, before his arrival, were highly fashionable and eminent; but by this foreign interloper were driven into the greatest distress and poverty.

*Vanloo came to England, with his son, in 1737.—Note by John Ireland quoting Horace Walpole

By this inundation of folly and fuss, I must confess, I was much disgusted, and determined to try if by any means I could stem the torrent, and *by opposing end it*. I laughed at the pretensions of these quacks in colouring, ridiculed their productions as feeble and contemptible, and asserted that it required neither taste nor talents to excel their most popular performances. This interference excited much enmity, because, as my opponents told me, my studies were in another way. You talk, added they, with ineffable contempt of portrait painting; if it is so easy a task, why do not you convince the world by painting a portrait yourself. Provoked at this language, I one day, at the Academy in St Martin's Lane, put the following question: Supposing any man at this time were to paint a portrait as well as Vandyke, would it be seen or acknowledged, and could the artist enjoy the benefit, or acquire the reputation, due to his performance?

They asked me, in reply, if I could paint one as well? and I frankly answered, "I believed I could." My query as to the credit I should obtain if I did, was replied to by Mr. Ramsay, and confirmed by the president and about twenty members present: "Our opinions must be consulted, and we will never allow it." Piqued at this cavalier treatment, I resolved to try my own powers, and if I did what I attempted, determined to

affirm that I had done it. In this decided manner I had a habit of speaking, and if I only did myself justice, to have adopted half words would have been affectation. Vanity, as I understand it, consists in affirming you have done that which you have not done,—not in frankly asserting what you are convinced is truth.

A watchmaker may say, "The watch which I have made for you, is as good as Quare, or Tompion, or any other man could have made." If it really is so, he is neither called vain, nor branded with infamy, but deemed an honest and fair man, for being as good as his word. Why should not the same privilege be allowed to a painter? The modern artist, though he will not warrant his works as the watchmaker, has the impudence to demand twice as much money for painting them, as was charged by those whom he acknowledges his superiors in the art.

Of the mighty talents said to be requisite for portrait painting, I had not the most exalted opinion, and thought that, if I chose to practice in this branch, I could at least equal my contemporaries, for whose glittering productions I really had not much reverence. In answer to this, there are who will say with Peachum in the play, "all professions berogue one another"—but let it be taken into the account, that men with the same pursuits are naturally rivals, and when

put in competition with each other, must necessarily be so: what racer ever wished that his opponent might outrun him? what boxer ever chose to be beat in pure complaisance to his antagonist? The artist who pretends to be pleased and gratified when he sees himself excelled by his competitor, must have lost all reverence for truth, or be totally dead to that spirit which I believe to be one great source of excellence in all human attempts; and if he is so polite and civil, as to confess superiority in one he knows to be his inferior, he must be either a fool or an hypocrite; perhaps both. If he has temper enough to be silent, it is surely sufficient; but this I have seldom seen, even amongst the most complaisant and liberal of the faculty.

Those who will honestly speak their feelings must confess that all this is natural to man; one of the highest gratifications of superiority, arises from the pleasure which attends instructing men who do not know so much as ourselves; but when they verge on being rivals, the pleasure in a degree ceases. Hence the story of Rubens advising Vandyke to paint horses and faces, to prevent, as it is said, his being put in competition with himself in history painting. Had either of these great artists lived in England at this time, they would have found men of very moderate parts—mere face painters, who, if they chanced to be in vogue, might

with ease get a thousand a year; when they, with all their talents, would scarcely have found employment.

To return to my dispute with Mr. Ramsay on the abilities necessary for portrait painting; as I found the performances of professors in this branch of the art were held in such estimation, I determined to have a brush at it. I had occasionally painted portraits, but as they required constant practice to take a likeness with facility, and the life must not be rigidly followed, my portraitures met with a fate somewhat similar to those of Rembrandt. By some they were said to be nature itself, by others declared most execrable; so that time only can decide whether I was the best or the worst face painter of my day; for a medium was never so much as suggested.

The portrait which I painted with most pleasure, and in which I particularly wished to excel, was that of Captain Coram, for the Foundling Hospital;[1] and if I am so wretched an artist as my enemies assert, it is somewhat strange that this, which was one of the first I painted the size of life, should stand the test of twenty years competition, and be generally thought the best portrait in the place, notwithstanding the first painters in the kingdom exerted all their talents to vie

1. 1740. Still in situ, Foundling Hospital, London

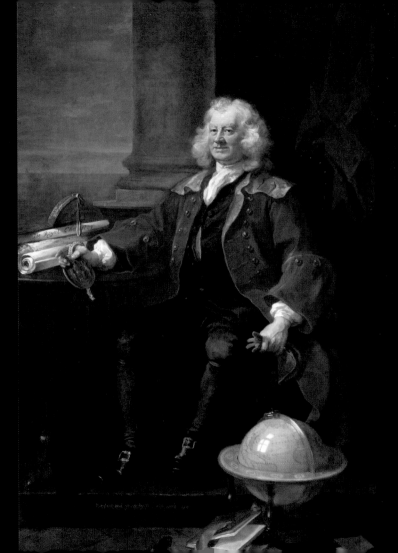

with it.* To this I refer Mr. Rams-eye, and his quick-sighted and impartial coadjutors.†

For the portrait of Mr. Garrick in *Richard III* [1] I was paid two hundred pounds (which was more than any English artist ever received for a single portrait), and that too by the sanction of several painters who had not been previously consulted about the price, which was not given without mature consideration.

Notwithstanding all this, the current remark was, that portraits were not my province; and I was tempted to abandon the only lucrative branch of my art, for the practice brought a whole nest of phiz-mongers

*The rival portraits here alluded to, are, George the Second, patron of the foundation, by Shackleton; Lord Dartmouth, one of the vice-presidents, by Mr. Reynolds (afterwards Sir Joshua); Taylor White, treasurer of the hospital, in crayons, by Coates; Mr. Milner and Mr. Jackson, by Hudson; Dr. Mead, by Ramsay; Mr. Emmerson, by Highmore; and Francis Fauquier, Esq., by Wilson. To say that it is superior to these, is but slight praise; independent of this relative superiority, it will not be easy to point out a better painted portrait. The head, which is marked with uncommon benevolence, was, in 1739, engraved in mezzo-tinto, by M'Ardell.—Note by John Ireland

†Thus does Hogarth pun upon the name of Mr. Ramsay, who he seems to think peered too closely into his prints; though he acknowledged, that in a book entitled the *Investigator*, Ramsay has treated him with more candour than any of his other opponents.—Note by John Ireland

1. 1745, Walker Art Gallery, Liverpool

*Opposite: Captain Thomas Coram, 1740*

*David Garrick as*
*Richard III, c. 1745*

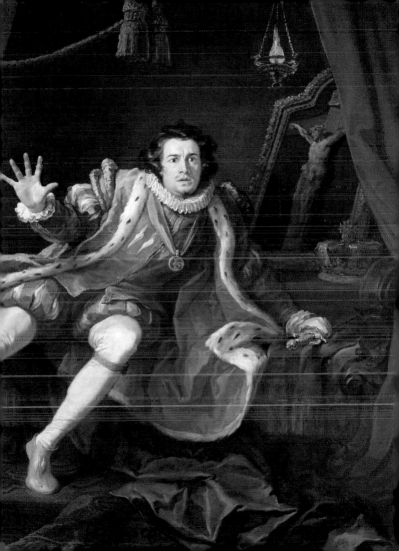

on my back, where they buzzed like so many hornets. All these people have their friends, whom they incessantly teach to call my women harlots, my Essay on Beauty borrowed. And my composition and engraving contemptible.

This so much disgusted me, that I sometimes declared I would never paint another portrait, and frequently refused when applied to; for I found by mortifying experience, that whoever would succeed in this branch, must adopt the mode recommended in one of Gay's fables, and make divinities of all who sit to him.* Whether or not this childish affectation will ever be done away, is a doubtful question; none of those who have ever attempted to reform it have yet succeeded; nor, unless portrait painters in general become more honest, and their customers less vain, is there much reason to expect they ever will.

*The fable here alluded to, is entitled, a Painter who pleased every body and nobody: *"So very like a painter drew, / That every eye the picture knew / His honest pencil touch'd with truth, / And mark'd the date of age and youth."* But see the consequence,—*"In dusty piles his pictures lay, / For no one sent the second pay."* Finding the result of truth so unpropritious to his fame and fortune, he changed his practice: *"Two bustos fraught with every grace. / A Venus, and Apollo's face, / He placed in view;—resolv'd to please, / Whoever sat, he drew from these."* This succeeded to a tittle,— *"Through all the town his art they prais'd, / His custom grew, his price was rais'd."*—Note by John Ireland

# CHAPTER THREE

*Of Academies; Hogarth's opinion of that now
denominated Royal; and of the Society for the
Encouragement of Arts, Manufactures, and Commerce,
giving premiums for pictures and drawings*

*Receiv'd* of
5 Shillings being the first Payment for two large Prints
one representing *Moses* brought to *Pharoah's Daughter.*
The other *St Paul* before *Felix*, wch I Promise to deliver
when finish'd, on Receiving 5 Shillings more.

N.B. They will be Seven and Six Pence
each Print, after the time of Subscribing.

Much has been said about the immense benefit likely to result from the establishment of an Academy in this country, but as I do not sit in the same light with many of my contemporaries, I shall take the freedom of making my objections to the plan on which they propose forming it; and as a sort of preliminary to the subject, state some slight particulars concerning the fate of former attempts at similar establishments.

The first place of this sort was in Queen-street, about sixty years ago; it was begun by some gentlemen-painters of the first rank, who in their general forms imitated the plan of that in France, but conducted their business with far less fuss and solemnity; yet the little that there was, in a very short time became the object of ridicule. Jealousies arose, parties were formed, and the president and all his adherents found themselves comically represented, as marching in ridiculous procession round the walls of the room. The first proprietors soon put a padlock on the door; the rest, by their right as subscribers, did the same, and thus ended this Academy.

Sir James Thornhill, at the head of one of these parties, then set up another in a room he built at the

*Opposite: Boys peeping at Nature, 1751. A receipt ticket for two prints*

back of his own house, now next the playhouse, and furnished tickets gratis to all that required admission; but so few would lay themselves under such an obligation, that this also soon sunk into insignificance. Mr. Vanderbank headed the rebellious party, and converted an old Presbyterian meeting-house into an Academy, with the addition of a woman figure, to make it the more inviting to subscribers. This lasted a few years; but the treasurer sinking the subscription money, the lamp, stove, &c. were seized for rent; and that also dropped.

Sir James dying, I became possessed of his neglected apparatus; and thinking that an Academy conducted on proper and moderate principles had some use, proposed that a number of artists should enter into a subscription for the hire of a place large enough to admit thirty or forty people to draw after a naked figure. This was soon agreed to, and a room taken in St Martin's Lane. To serve the society, I lent them the furniture which had belonged to Sir James Thornhill's academy; and as I attributed the failure of that and Mr. Vanderbank's to the leading members assuming a superiority which their fellow-students could not brook, I proposed that every member should contribute an equal sum to the establishment, and have an equal right to vote in every question relative

to the society. As to electing presidents, directors, professors, &c. I considered it as a ridiculous imitation of the foolish parade of the French Academy, by the establishment of which Louis XIV got a large portion of fame and flattery on very easy terms. But I could never learn that the arts were benefited, or that members acquired any other advantages than what arose to a few leaders from their paltry salaries, not more I am told than fifty pounds a year; which, as must always be the case, were engrossed by those who had most influence, without any regard to their relative merit. As a proof of the little benefit the arts derived from this Royal Academy, Voltaire asserts that, after its establishment, no one work of genius appeared in the country; the whole band, adds the same lively and sensible writer, became mannerists and imitators.* It may be said in answer to this, that all painting is but imitation: granted; but if we go no further than copying what has been done before, without entering into the spirit, causes, and effects, what are we doing? If we vary from our original, we fall off from it, and it ceases to be a copy; and if we strictly adhere to it, we

*Louis XIV founded an academy for the French at Rome; but Poussin and Le Sueur, painters who have done the most credit to France, were prior to the establishment.—Note by John Ireland

can have no hopes of getting beyond it; for if two men ride on a horse, one of them must be behind.

To return to our own Academy; by the regulations I have mentioned of a general equality, &c., it has now subsisted near thirty years; and is, to every useful purpose, equal to that in France, or any other; but this does not satisfy. The members finding his present Majesty's partiality to the arts, met at the Turk's Head in Gerrard-street, Soho; laid out the public money in advertisements, to call all sorts of artists together; and have resolved to draw up and present a ridiculous address to King, Lords, and Commons, to do for them, what they have (as well as it can be) done for themselves. Thus to pester the three great estates of the empire, about twenty or thirty students drawing after a man or a horse, appears, as it must be acknowledged, foolish enough; but the real motive is, that a few bustling characters, who have access to people of rank, think they can thus get a superiority over their brethren, be appointed to places, and have salaries as in France, for telling a lad when an arm or a leg is too long or too short.

Not approving of this plan, I opposed it; and having refused to assign to the society the property which I had before lent them, I am accused of acrimony, ill nature, and spleen, and held forth as an enemy to the

arts and artists. How far their mighty project will succeed, I neither know nor care; certain I am it deserves to be laughed at, and laughed at it has been. The business rests in the breast of Majesty, and the simple question now is,—whether he will do, what Sir James Thornhill did before him, i.e. establish an Academy, with the little addition of a royal name, and salaries for those professors who can make most interest and obtain the greatest patronage. As his Majesty's beneficence to the arts will unquestionably induce him to do that which he thinks most likely to promote them, would it not be more useful, if he were to furnish his own gallery with one picture by each of the most eminent painters among his own subjects? This might possibly set an example to a few of the opulent nobility; but, even then, it is to be feared that there never can be a market in this country for the great number of works which, by encouraging parents to place their children in this line, it would probably cause to be painted. The world is already glutted with these commodities, which do not perish fast enough to want such a supply.

In answer to this, and other objections which I have sometimes made to those who display so much zeal for increasing learners, and crowding the profession, I am asked, if I consider what the arts were in Greece?

What immense benefits accrued to the city of Rome from the possession of their works? And what advantage the people of France derive from the encouragement given by their Royal Academy? It is added, why cannot we have one on the same principles? That we may not be led away by sounds without meaning, let us take a cursory view of these things separately, and in the same order that they occurred.

The height to which the arts were carried in Greece, was owing to a variety of causes, concerning some of which we can only now form conjectures. They made a part of their system of government, and were connected with their modes of worship. Their temples were crowded with deities of their own manufacture, and in places of public resort were depicted such actions of their fellow-citizens, as deserved commemoration, which being displayed in a language legible to all, incited the spectator to emulate the virtues they represented. The artists who could perform such wonders, were held in an estimation of which we can hardly form an idea; and could we ascertain the rewards they received, I think it would be found that they were most liberally paid for their works, and might therefore devote much more time than we can afford to rendering them perfect.

With all this, even there, the arts had but a slow

risc; and when they had attained their highest state of perfection, the Romans (having previously plundered and butchered their own neighbours) attacked and conquered the Greeks, and robbed them of their portable treasures, particularly their statues and pictures.* To sculpture and painting, war is a most destructive enemy; the rage of conquest, civil broils, and intestine quarrels, necessarily put a stop to the exercise of the imitative arts, which lay in a dormant state until they were revived by the introduction of a new religion; this, in the magnificent style it was there brought forward, called upon sculpture and painting for their auxiliary aid. The admirable specimens that, during the perturbed period above all alluded to, had been hidden in the earth, were now restored to light, eagerly sought for, and in some cases appropriated to purposes diametrically opposed to their pagan origin. Even those that were mutilated, were held in the most enthusiastic admiration. The Torso, and many other imitable specimens, prove that their admiration was

---

* Of the estimation in which they were held, and the taste with which they were contemplated with the Romans, we may form some judgment, by a general assuring a soldier, to whom he gave in charge a statue, which was the work of Praxiteles, that if he broke it, he should get another as good made in its place.

just. The contemplation of such works would naturally produce imitators, who in time rivalled, but never could equal, their originals. These remains of ancient grandeur being thus added to their new productions, and both interwoven, forming a sort of ornamental fringe to their gaudy religion, Rome became a kind of puppet-show to the rest of Europe; and whatever it might be to their visitors, was certainly very advantageous to themselves. The arts are much indebted to Popery, and that religion owes much of its universality to the arts.

France, ever aping the magnificence of other nations, has in its turn assumed a foppish kind of splendour sufficient to dazzle the eyes of the neighbouring states, and draw vast sums of money from this country. We cannot vie with these Italian and Gallic theatres of art, and to enter into competition with them is ridiculous; we are a commercial people, and can purchase their curiosities ready-made, as in fact we do, and thereby prevent their thriving in our native clime. If I may be permitted to compare great things with small, this nation labours under similar disadvantage to the playhouse in Goodman's Fields, which, though it might injure, could never rival, the two established theatres, so much more properly situated, in any degree material to itself.

In Holland, selfishness is the ruling passion; in England, vanity is united with it. Portrait painting therefore ever has, and ever will succeed better in this Country than in any other; the demand will be as constant as new faces arise; and with this we must be contented, for it will be in vain to attempt to force what can never be accomplished; or at least can never be accomplished by such institutions as Royal Academies on the system now in agitation. Upon the whole, it must be acknowledged that the artists and the age are fitted for each other. If hereafter the times alter, the arts, like water, will find their level.

Among other causes that militate against either painting or sculpture succeeding in this nation, we must place our religion; which, inculcating unadorned simplicity, doth not require, nay absolutely forbids, images for worship, or pictures to excite enthusiasm. Paintings are considered as pieces of furniture, and Europe is already overstocked with the works of other ages. These, with copies, countless as the sands on the seashore, are bartered to and fro, and are quite sufficient for the demands of the curious; who naturally prefer scarce, expensive, and far-fetched productions, to those which they might have on low terms at home. Who can be expected to give forty guineas for a modern landscape, though in ever so superior a style, when

he can purchase one, which, for little more than dou-
ble the sum, shall be sanctioned by a sounding name,
and warranted original by a solemn-faced connois-
seur? This considered, can it excite wonder that the
arts have not taken such deep root in this soil as in
places where the people cultivate them from a kind
of religious necessity, and where proficients have so
much more profit in the pursuit? Whether it is to our
honour or disgrace, I will not presume to say, but the
fact is indisputable, that the public encourage trade
and mechanics, rather than painting and sculpture.
Is it then reasonable to think, that the artist, who, to
attain essential excellence in his profession, should
have the talents of a Shakespeare, a Milton, or a Swift,
will follow this tedious and laborious study merely for
fame, when his next door neighbour, perhaps a porter-
brewer, or an haberdasher of small wares, can without
any genius accumulate an enormous fortune in a few
years, become a Lord Mayor, or a Member of Parlia-
ment, and purchase a title for his heir? Surely no;—for,
as very few painters get even moderately rich, it is not
reasonable to expect, that they should waste their lives
in cultivating the higher branch of the art, until their
country becomes more alive to its importance, and
better disposed to reward their labours.

These are the true causes that have retarded our

progress; and for this, shall a nation which has, in all ages, abounded in men of sound understanding, and the brightest parts, be branded with incapacity, by a set of pedantic dreamers, who seem to imagine that the degrees of genius are to be measured like the degrees on a globe,—determine a man's powers from the latitude in which he was born,—and think that a painter, like certain tender plants, can only thrive in a hot-house? Gross as are these absurdities, there will always be a band of profound blockheads ready to adopt and circulate them if it were only upon the authority of the great names by which they are sanctioned.

To return to our Royal Academy, I am told that one of their leading objects will be, sending young men abroad to study the antique statues, &c. Such kind of studies may sometimes improve an exalted genius, but they will not create it; and whatever has been the cause, this same travelling to Italy has, in several instances that I have seen, seduced the student from nature, and led him to paint marble figures, in which he has availed himself of the great works of antiquity, as a coward does when he puts on the armour of an Alexander; for, with similar pretensions, and similar vanity, the painter supposes he shall be adored as a second Raphael Urbino.

The fact is, that every thing necessary for the student, in sculpture or painting, may at this time be procured in London. Of the Venus, and the Gladiator, we have small casts; and even the Torso, by which Michael Angelo asserted he learned all he knew of the art, has been copied in a reduced size, and the cast, by which the principle may be clearly seen, is sold for a few shillings. These small casts, if quite correct, are full as useful to the student as the originals; the parts are easier comprehended; they are more portable to place in different lights; and of an even colour: while the old Parian marbles are apt to shine, dazzle, and confound the eye. If this be doubted, let a plaster figure be smoked and oiled, and the true dimensions of the muscles can be no more distinguished than those of a sooty chimney-sweeper.

After all, though the best statues are unquestionably, in parts, superlatively fine, and superior to nature, yet they have invariably a something that is inferior.

As to pictures, there are enough in England to seduce us from studying nature, which every man ought to do, if he aims at any higher rank than being an imitator of the works of others; and to such servile spirits I will offer no advice.

In one word, I think that young men by studying in Italy have seldom learnt much more than the names

of the painters; though sometimes they have attained the amazing power of distinguishing styles,* and knowing by the hue of the picture the hard name of the artist, a power which, highly as they pride themselves upon it, is little more than knowing one handwriting from another. For this they gain great credit, and are supposed vast proficients, because they have travelled. They are gravely attended to by people of rank, with whom they claim acquaintance, and talk of the antique in a cant phraseology, made up of half or whole Italian, to the great surprise of their hearers, who become gulls, in order to pass for connoisseurs,—wonder with a foolish face of praise—and bestow unqualified admiration on the marvellous bad copies of marvellous bad originals, which they have brought home as trophies, and triumphantly display, to prove their discernment and taste.

Neither England nor Italy ever produced a more contemptible dauber than the late Mr. Kent,—and yet he gained the prize at Rome, in England had the first people for his patrons, and, to crown the whole, was appointed painter to the king. But in this country

---

* Their mode of judging, subjects them to continual imposition; for what is called manner, is easily copied by the lowest performer;—he only fails in beauty, delicacy, and spirit!

The Analysis of
Beauty, Plate 1,
1753

Designed, Engraved, and Publish'd by W.ᵐ Hogarth, March 5.ᵗʰ 1753, according to Act of Parliament.

such men meet with the greatest encouragement, and soonest work their way into noblemen's houses and palaces. To conclude,—I think that this ostentatious establishment can answer no one valuable purpose to the arts, nor be of least use to any individual, except those who are to be elected professors, and receive salaries, for the kind superintendence they will exercise over such of their brethren as have not so much interest as themselves.

Many of the objections which I have to the institution of this Royal Academy, apply with equal force to the project of the Society for the Encouragement of Arts, Manufactures, and Commerce, for distributing premiums for drawings and pictures; subjects of which they are totally ignorant, and in which they can do no possible service to the community. It is extremely natural for noblemen, or young people of fortune, who have travelled, and seen fine pictures and statues, to be planet-struck with a desire of being celebrated in books, like those great men of whom they have read in the lives of the painters, &c.; for it must be recollected that the popes, princes, and cardinals, who patronized these painters, have been celebrated as creators of the men who created those great works:—

"Shar'd all their honours, and partook their fame."

The Dilettanti had all this in prospect, when they offered to establish a drawing school, &c., at their own expense; for here they expected to be paramount. But when those painters, who projected the scheme, presumed to bear a part in the direction of the school, the Dilettanti kept their money, and rejected them with scorn,—the whole castle fell to the ground, and has been no more heard of.

This society of castle-builders have a similar idea. They wish first to persuade the world, that no genius can deserve notice without being first cultivated under their direction; and will ultimately neither foster nor encourage any artist that has not been brought up by themselves.

The sounding title of a Society for the Encouragement of Arts, Manufactures, and Commerce, with two or three people of rank at their head, attracted a multitude of subscribers. Men, when repeatedly applied to, were unwilling to refuse two guineas a year; people of leisure, tired of public amusements, found themselves entertained with formal speeches, from men who had still more pleasure in displaying their talents for oratory. Artificers of all descriptions were invited, and those who were not bidden, strained every nerve to become members, and appear on the printed list, as promoters of the fine arts. By this means, they

were consulted in their several professions, and happy was he who could assume courage enough to speak, though ever so little to the purpose.

The intention of this great Society is unquestionably laudable,—their success in subscriptions astonishing. How far their performances have been equal to their promises, it is not my business to inquire; but as, while I had the honour of being a member, my opinion was frequently asked on some points relating to my own profession, I venture to lay it before the reader, with the same frankness that I then gave it.

When the Society was in its infancy, they gave premiums for children's drawings, and for this—let children lisp their praise. It was asserted that we should thus improve our own manufactures, and gravely asked by these professed encouragers of the commerce of their country, if the French children, being instructed in drawing, did not enable that people to give a better air to all the articles they fabricated. I answered positively, no; and added, that thus trumpeting their praise, was a degradation of our own country, and giving to our rivals a character which they had no right to. Were this point debated, French superiority would be supported by fashionable ladies, travelled gentlemen, and picture dealers. In opposition to them, would be those who are capable of judging for

themselves, the few that are not led away by popular prejudices, and the first artists in the kingdom. These, I am conscious, would be a minority; but composed of men that ought to have weight, and whose opinion and advice should have been taken before the plan was put in execution.

Of the immense improvement that is to take place in our manufactures, from boys of almost every profession being taught to draw, I form no very sanguine expectations.

To attain the power of imitating the forms of letters with freedom and precision in all their due proportions and various elegant turns, as Snell has given them, requires as much skill as to copy different forms of columns and cornices in architecture, and might with some show of propriety be said to demand a knowledge of design; yet common sense and experience convince us, that the proper place for acquiring a fine hand is a writing-school. As measuring is but measuring, I do not think that a tailor would make a suit of clothes fit better, from having been employed twice seven years in taking the dimensions of all the bits of antiquity that remain in Greece.* How absurd

* Swift's Laputa tailor made all his clothes by mathematical rules, and there was no objection to them,—except that they never fitted those for whom they were made.

would it be to see perriwig-makers' and shoemakers' boys learning the art of drawing, that they might give grace to a peruke or a slipper. If the study of Claude's landscapes would benefit the carver of a picture frame, or the contemplation of a finely painted sauce-pan by Teniers, or Basson, would be an improvement to a tinman, it would be highly proper for this Society to encourage them in the practice of the arts. But as this is not the case, giving lads of all ranks a little knowledge of everything, is almost as absurd as it would be to instruct shopkeepers in oratory, that they may be thus enabled to talk people into buying their goods, because oratory is necessary at the bar and in the pulpit. As to giving premiums to those that design flowers, &c. for silks and linens, let it be recollected that these artisans copy the objects they introduce from nature; a much surer guide than all the childish and ridiculous absurdities of temples, dragons, pago-das, and other fantastic fripperies, which have been imported from China.

As from all these causes (and many more might be added), it appears that a smattering in the arts can be of little use, except to those who make painting their sole pursuit, why should we tempt such multitudes to embark in a profession by which they never can be supported? For historical pictures there never can

be a demand: our churches reject them; the nobility prefer foreign productions; and the generality of our apartments are too small to contain them. A certain number of portrait painters, if they can get patronized by people of rank, may find employment; but the majority, even of these, must either shift how they can amongst their acquaintance, or live by travelling from town to town like gypsies. Yet, as many will be allured by flattering appearances, and form vague hopes of success, some of the candidates must be unsuccessful, and men will be rendered miserable, who might have lived comfortably enough by almost any manufactory, and will wish that they had been taught to make a shoe, rather than thus devoted to the polite arts. When I once stated something like this to the Society, a member humanely remarked, that the poorer we kept the artists, the cheaper we might purchase their works.*

*In ridicule of the preference given to old pictures, Hogarth exercised not only his pencil but his pen. His advertisement for*

---

*How far Hogarth's prediction has been fulfilled, by the repentance of some painters, who may have been thus dragged into the temple of taste, those painters only can determine.—Note by John Ireland

WILLIAM HOGARTH

*the sale of the paintings of Marriage A-la-Mode, inserted in a* Daily Advertiser *of 1750, thus concludes:*

> As according to the standard so righteously and laudably established by picture-dealers, picture-cleaners, picture-frame-makers, (and other connoisseurs), the works of a painter are to be esteemed more or less valuable, as they are more or less scarce, and as the living painter is most of all affected by the inferences resulting from this and other considerations equally candid and edifying, Mr. Hogarth by way of precaution, not puff, begs leave to urge, that probably this will be the last sale of pictures he may ever exhibit, because of the difficulty of vending such a number at once to any tolerable advantage: and that the whole number he has already exhibited of the historical or humourous kind does not exceed fifty; of which the three sets called the Harlot's Progress, the Rake's Progress, and that now to be sold, make twenty; so that whoever has a taste of his own to rely on, and is not too squeamish, and has courage enough to own it, by daring to give them a place in a collection till Time, (the supposed finisher, but real destroyer of paintings,) has rendered them fit for those more sacred repositories where schools, names, heads, masters, &c. attain their last stage of preferment, may from hence be convinced, that multiplicity at least, of his, Mr. Hogarth's, pieces, will be no diminution of their value.

*The annexed letter Mr. John Ireland was informed was written by Hogarth; add to this authority, of which he had no doubt, it carries internal evidence of his mind. It is printed in the* London Magazine *for 1737, and thus prefaced:*

The following piece, published in the *St. James's Evening Post* of June 7th, is by the first painter in England, —perhaps in the world in his way.

Every good-natured man and well-wisher to the Arts in England, must feel a kind of resentment at a very indecent paragraph, in the *Daily Post* of Thursday last, relating to the death of M. le Moine, first painter to the French King; in which very unjust, as well as cruel reflections, are cast on the noblest performance (in its way) that England has to boast of; I mean the work of the late Sir James Thornhill in Greenwich Hall. It has ever been the business of narrow, little geniuses, who by a tedious application to minute parts, have (as they fancy) attained to a great insight into the correct drawing of a figure, and have acquired just knowledge enough in the art to tell accurately when a toe is too short, or a finger too thick, to endeavour, by detracting from the merits of great men, to build themselves a kind of reputation. These peddling demi-critics, on the painful discovery of some little inaccuracy (which proceeds mostly from the freedom of the pencil), without any regard to the more noble parts of a

performance (which they are totally ignorant of), with great satisfaction condemn the whole as a bad and incorrect piece.

> The meanest artist in the Emilian square.
> Can imitate in brass the nails or hair;
> Expert at trifles, and a conning fool.
> Able to express the parts, but not the whole.

There is another set of gentry, more noxious to the art than these, and those are your picture jobbers from abroad, who are always ready to raise a great cry in the prints, whenever they think their craft is in danger; and indeed it is their interest to depreciate every English work as hurtful to their trade of continually importing ship-loads of dead Christs, Holy Families, Madonnas, and other dismal dark subjects, neither entertaining nor ornamental, on which they scrawl the terrible cramp names of some Italian masters, and fix on us poor Englishmen the character of universal dupes. If a man, naturally a judge of painting, not bigotted to those empyrics, should cast his eye on one of their sham virtuoso pieces, he would be very apt to say, 'Mr. Bubbleman, that grand Venus, as you are pleased to call it, has not beauty enough for the character of an English cook-maid.'—Upon which the

*Opposite: Time Smoking a Picture, c. 1761. The Greek inscription above the picture translates as 'Time is not a great artist, but weakens all he touches'*

Crates

Χρονος γαρ ου τεχτων σοφος,
Απαντα δ' εργαζομενος ασενεστερα

*See Spectator*
*Vol: II. Page 23.*

VARNISH.

_____ As Statues moulder into Worth *P. W.*

*To Nature and your Self appeal,*
*Nor learn of others, what to feel.* Anon:

quack answers, with a confident air, 'Sir, I find that you are no connoisseur; the picture, I assure you, is in Alesso Baldovinetto's second and best manner, boldly painted, and truly sublime: the contour gracious; the air of the head in the high Greek taste; and a most divine idea it is.'—Then spitting in an obscure place, and rubbing it with a dirty handkerchief, takes a skip to t'other end of the room, and screams out in raptures,—'There's an amazing touch! A man should have this picture a twelvemonth in his collection before he can discover half its beauties!' The gentleman (though naturally a judge of what is beautiful, yet ashamed to be out of the fashion, by judging for himself) with this cant is struck dumb; gives a vast sum for the picture, very modestly confesses he is indeed quite ignorant of painting, and bestows a frame worth fifty pounds on a frightful thing, which, without the hard name, is not worth so many farthings. Such impudence as is now continually practised in the picture trade must meet with its proper treatment, would gentlemen but venture to see with their own eyes. Let but the comparison of pictures with nature be their only guide, and let them judge as freely of painting as they do of poetry, they would then take it for granted, that when a piece gives pleasure to none but these connoisseurs or their adherents, if the purchase be a thousand pounds, 'tis nine hundred and ninety-nine too dear; and were all our grand collections stripped of such

sort of trumpery, then, and not till then, it would be worth an Englishman's while to try the strength of his genius to supply their place; which now it were next to madness to attempt, since there is nothing that has not travelled a thousand miles, or has not been done a hundred years, but is looked upon as mean and ungenteel furniture. What Mr. Pope in his last work says of poems, may with much more propriety be applied to pictures:

> Authors, like coins, grow dear as they grow old;
> It is the rust we value, not the gold.

Sir James Thornhill, in a too modest compliance with the connoisseurs of his time, called in the assistance of Mr. André, a foreigner, famous for the fullness of his outline, to paint the royal family at the upper end of Greenwich Hall—to the beauties or faults of which I have nothing to say; but with regard to the ceiling, which is entirely of his own hand, I am certain all unprejudiced persons, with (or without) much insight into the mechanic parts of painting, are at the first view struck with the most agreeable harmony and play of colours that ever delighted the eye of a spectator. The composition is altogether extremely grand, the groups finely disposed, the light and shade so contrived as to throw the eye with pleasure on the principal figures, which are drawn with great fire and

judgment; the colouring of the flesh delicious, the drapery great, and well folded, and upon examination, the allegory is found clear, well invented, and full of learning: in short, all that is necessary to constitute a complete ceiling-piece, is apparent in that magnificent work. Thus much, is in justice to that great English artist from an Englishman,

<div style="text-align: right;">BRITOPHIL.</div>

N.B. If the reputation of this work were destroyed, it would put a stop to the receipt of daily sums of money from spectators, which is applied to the use of sixty charity-children.

## CHAPTER FOUR

*The motives by which Hogarth was induced to publish his* Analysis of Beauty; *the abuse it drew upon him, and his vindication of himself and his work*

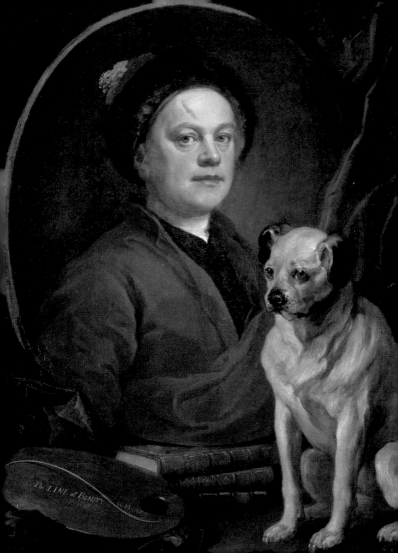

"What! a book, and by Hogarth! then twenty to ten,
All he's gained by the pencil he'll lose by the pen."

"Perhaps it may be so—howe'er, miss or hit.
He will publish—here goes—it's double or quit."

—Epigram by Hogarth

*Hogarth, finding his prints were become sufficiently numerous to form a handsome volume, in the year 1745 engraved his own portrait as a frontispiece. In one corner of the plate he introduced a painter's palette, on which was a waving line inscribed* The Line of Beauty. *This created much speculation, and, as he himself expresses it:*

The bait soon took, and no Egyptian hiero-glyphic ever amused more than it did for a time; painters and sculptors came to me to know the meaning of it, being as much puzzled with it as other people, till it came to have some explanation; then, indeed, but not till then, some found it out to be an old acquaintance of theirs,*

* To this he evidently alludes, in giving the well-known story of Columbus breaking the egg, as a subscription receipt to his *Analysis of Beauty.*—Note by John Ireland

*Opposite: Self-portrait with his pug, Trump, 1745*

though the account they could give of its properties was very near as satisfactory as that which a day-labourer, who constantly uses the lever, could give of that machine as a mechanical power. They knew it, as Falstaff did Prince Henry—by instinct!

*This crooked line drew upon him a numerous band of opponents, and involved him in so many disputes, that he at length determined to write a book, explain his system, and silence his adversaries.*

My preface and introduction to the *Analysis* contain a general explanation of the circumstances which led me to commence author; but this has not deterred my opponents from loading me with much gross, and I think unmerited obloquy; it therefore becomes necessary that I should try to defend myself from their aspersions.

Among many other high crimes and misdemeanours, of which I am accused, it is asserted that I have abused the great masters. This is so far from being just, that when the truth is fairly stated, it may possibly appear, that the professional reputation of these luminaries of the arts, is more injured by the wild and enthusiastic admiration of those who denominate

themselves their fast friends, than by men who are falsely classed their enemies.

Let us put a case: suppose a brilliant landscape had been so finely painted by a first-rate artist, that the trees, water, sky, &c. were boldly, though tenderly relieved from each other, and the eye of the spectator might, as it were, travel into the scenery; and suppose this landscape, by the heat of the sun, the ravages of time, or the still more fatal ravages of picture-cleaners, was shorn of its beams, and deprived of all its original brightness; let me ask, whether the man who will affirm that this almost obliterated, unharmonious, spotty patchwork piece of antiquity is in the state that it first came out of the artist's hands, does not abuse the painter? and whether he who asserts, that though it might once have been bright and clear, it is now faded, does not thus place the defects to the proper account; and consequently defend him?

So far from attempting to lower the ancients, I have always thought, and it is universally admitted, that they knew some fundamental principles in nature, which enabled them to produce works that have been the admiration of succeeding ages; but I have not allowed this merit to those leaden-headed imitators, who, having no consciousness of either symmetry or propriety, have attempted to mend nature, and,

in their truly ideal figures, gave similar proportions to a Mercury and a Hercules.

This, and many other opinions which I have ventured to advance, has roused a nest of hornets, from whose stings I would wish to guard myself, as I am conscious that they will try to condemn all my works by my own rules. To disappoint these insects, I have, in my explanatory prints, done the Antinous, Venus, &c. in a slighter style than the other figures, to show that they are introduced as mere references to the originals; and I will not now attempt to paint my Goddess of Beauty. Who can tell how long the artist was employed in giving such exquisite grace to the Grecian Venus? He might, perhaps, think that a single super-excellent statue would confer immortality, and was sufficient for a whole life. Can any one expect to see equal perfection, in that which is done *in little*, and in a short space of time?

With respect to *beauty*, though men felt its effects, yet both artists and others appeared to me to be totally ignorant of its principles; and contented themselves with bestowing undistinguishing praise, and giving us cold and servile copies of the fine models of antiquity, without making any inquiry into the system by which they were produced. The few who wished to learn the principles, found themselves so bewildered and

confounded by the vague and contradictory opinions which they had heard and read concerning beauty and grace, that they began to suspect the whole to be an illusion, and that neither one nor the other existed except in fancy and imagination. This should excite less surprise, from its having sometimes happened in a matter of an infinitely higher and more important nature; and were it politically right, it is possible that a small octavo might be written, which would start as many folios of theological controversy as would fill Westminster Hall; though the whole put together might be mere lumber, and of no more use than waste paper. But this by the bye. To return into my own path, and resume the reasons that induced me to tread it in a new character. In doing this, it will be proper to give a succinct statement of the strange way in which this subject has been treated by preceding writers.

The first attempts that were made to fix true ideas of taste upon a surer basis, were by natural philosophers, who, in their amplified contemplations on the universal beauty displayed in the harmony and order of nature, very soon lost themselves; an event that, from the way in which they set out, was inevitable; for, if I may be permitted to adopt an allegorical figure, it necessarily led them into the wide *road of order and regularity*, which they unexpectedly found crossed

and intersected by many other paths, that led into the *labyrinths of variety*; where, not having passed through the *province of painting*, they became confused and could never find their way. To explaining the order and usefulness of nature they might be equal; but of her sportiveness and fancy, they were totally ignorant. To extricate themselves from these difficulties, they ascended the *mound of moral beauty*, contiguous to the open *field of divinity*, where rambling and ranging at large, they lost all remembrance of their former pursuit.

These gentlemen having failed, it was next suggested, that the deeply-read and travelled man, was the only person fully qualified to undertake the task of analysing beauty. But here let it be observed, that a few things well seen, and thoroughly understood, are more likely to furnish proper materials for this purpose, than the cursory view of all that can be met with in a hasty journey through Europe.

Nature is simple, plain, and true, in all her works, and those who strictly adhere to her laws, and closely attend to her appearances in their infinite varieties, are guarded against any prejudiced bias from truth; while those who have seen many things that they cannot well understand, and read many books which they do not fully comprehend, notwithstanding all their

pompous parade of knowledge, are apt to wander about it and about it, perpetually perplexing themselves and their readers with the various opinions of other men.

The knowledge necessary for writing a work on the arts, differs as much from that acquired by the simple traveller, as the art of simpling doth from the science of botany. Taking the grand tour, to see and pick up curiosities, which the travellers are taught nicely to distinguish from each other by certain cramp marks and hard names may with no great impropriety be termed going a-simpling; but with this special difference, that your field simpler never picks up a nettle for a marsh-mallow; a mistake which your tour simpler is very liable to.

As to those painters who have written treatises on painting, they were, in general, too much taken up with giving rules for the operative part of the art, to enter into physiological disquisitions on the nature of the objects. With respect to myself, I thought I was sufficiently grounded in the principles of my profession, to throw some new lights on the subject; and though the pen was to me a new instrument, yet, as the mechanic at his loom may possibly give as satisfactory an account of the materials and composition of the rich brocade he weaves, as the smooth-tongued

mercer, surrounded with all his parade of showy silks, I trusted that I might make myself tolerably understood, by those who would take the trouble of examining my book and prints together; for, as one who makes use of signs and gestures to convey his meaning in a language of which he has little knowledge, I have occasionally had recourse to my pencil. For this I have been assailed by every profligate scribbler in town, and told that, though words are man's province, they are not my province; and that, though I have put my name to the *Analysis of Beauty*, yet (as I acknowledge having received some assistance from two or three friends) I am only the supposed author. By those of my own profession I am treated with still more severity. Pestered with caricature drawings, and hung up in effigy in prints; accused of vanity, ignorance, and envy; called a mean and contemptible dauber; represented in the strangest employments, and pictured in the strangest shapes; sometimes under the hieroglyphical semblance of a satyr, and at others under the still more ingenious one of an ass.

Not satisfied with this, finding that they could not overturn my system, they endeavoured to wound the peace of my family. This was a cruelty hardly to be forgiven: to say that such malicious attacks and caricatures did not discompose me would be untrue, for

to be held up to public ridicule would discompose any man; but I must at the same time add, that they did not much distress me. I knew that those who venture to oppose received opinions, must in return have public abuse; so that, feeling I had no right to exemption from the common tribute, and conscious that my book had been generally well received, I consoled myself with the trite observation, that every success or advantage in this world must be attended by some sort of a reverse; and that, though the worst writers and worst painters have traduced me, by the best I have had more than justice done me. The partiality with which the world has received my works, and the patronage and friendship with which some of the best characters in it have honoured the author, ought to excite my warmest gratitude, and demand my best thanks. They enable me to despise this cloud of insects; for happily, though their buzzing may teaze, their stings are not mortal.

*On the 6th of June 1757, Hogarth was appointed "Serjeant Painter of all his Majesty's works, as well belonging to his Royal Palaces or houses, as to his great Wardrobe or otherwise." He thus notices the interest by which he obtained the places and its annual profits.*

Just after my brother's death, I obtained, by means of my friend Mr. Manning and the Duke of Devonshire, the office of Serjeant Painter, which might not have exceeded one hundred a year to me for trouble and attendance; but by two portraits,[1] at more than eighty pounds each, the last occasioned by his present Majesty's accession, and some other things, it has, for these last five years, been one way or other worth two hundred pounds per annum.

1. Unidentified

# CHAPTER FIVE

*Hogarth's inducement to paint the picture of* Sigismunda; *his correspondence with Lord Grosvenor on the subject, contrasted by two letters from Lord Charlemont, for whom he had previously painted an interesting scene; Origin of the Quarrel with Wilkes and Churchill, which gave rise to the Print of the* Bear, *&c.*

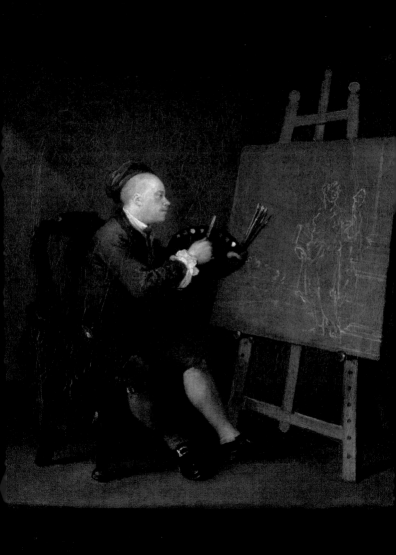

**B**eing thus driven out of the only profitable branch of my profession, I at first thought of attaching myself to history painting; but in this there was no employment; for in forty years I had only two orders of any consequence for historical pictures. This was rather mortifying; and being, by the profits of my former productions, and the office of Serjeant Painter, tolerably easy in my circumstances, and thoroughly sick of the idle quackery of criticism, I determined to quit the pencil for the graver. In this humble walk I had one advantage: the perpetual fluctuations in the manners of the times enabled me to introduce new characters, which being drawn from the passing day, had a chance of more originality, and less insipidity, than those which are repeated again and again, and again, from old stories. Added to this, the prints which I had previously engraved were now become a voluminous work, and circulated not only through England but over Europe. These being secured to me by an Act which I had previously got passed, were a kind of an estate; and as they wore, I could repair and re-touch them; so that in

*Opposite: Self-portrait, c. 1757-58. Painted in the year after he was appointed Serjeant Painter. When it was engraved Hogarth added his new title to the caption, and added a paint-pot behind his chair, emphasizing the practical nature of the appointment*

some particulars they became better than when first engraved.*

While I was making arrangements to confine myself entirely to my graver, an amiable nobleman (Lord Charlemont) requested that before I bade a final adieu to the pencil, I would paint him one picture. The subject to be my own choice, and the reward,—whatever I demanded. The story I pitched upon, was a young and virtuous married lady, who, by playing at cards with an officer, loses her money, watch, and jewels; the moment when he offers them back in return for her honour, and she is wavering at his suit, was my point of time.[1]

The picture was highly approved of, and the payment was noble; but the manner in which it was made, by a note enclosed in one of the following letters, was, to me, infinitely more gratifying than treble the sum.

---

* Hogarth might conceive that by rendering the habits of his early figures more conformable to the fashion of the times when they were altered, he improved them. Collectors are of a different opinion; though it must be acknowledged, that in Plate IV of the Rake's Progress, the humour is much heightened by introducing a group of vulgar minor gamblers, in the place of the shoeblack.—Note by John Ireland

1. *The Lady's Last Stake*, 1759, Albright-Knox Art Gallery, Buffalo, ill. pp. 112-13

FROM LORD CHARLEMONT

TO MR. HOGARTH

Mount-street, 19 August 1759

Dear Sir,

I have been so excessively busied with ten thousand troublesome affairs, that I have not been able to wait upon you according to my promise, nor even to find time to sit for my picture; as I am obliged to set out for Ireland tomorrow, we must defer that till my return, which will be in the latter end of January or in the beginning of February at farthest. I am still your debtor, more so indeed than I ever shall be able to pay; and did intend to have sent you before my departure what trifling recompence my abilities permit me to make you. But the truth is, having wrong calculated my expenses, I find myself unable for the present even to attempt paying you—However, if you be in any present need of money, let me know it, and as soon as I get to Ireland I will send you, not the price of your picture, for that is inestimable, but as much as I can afford to give for it.

Sir, I am, with the most sincere wishes for your health and happiness,

Your most obedient humble servant,

Charlemont

*The Lady's Last Stake, 1759.*
*The painting was originally known*
*as Picquet: or Virtue in Danger*

TO MR. HOGARTH

Dublin, 29 January 1760

Dear Sir,

Enclosed I send you a note upon Nesbitt for one hundred pounds; and considering the name of the author, and the surprising merit of your performance, I am really much ashamed to offer such a trifle in recompence for the pains you have taken, and the pleasure your picture has afforded me. I beg you would think that I by no means attempt to pay you according to your merit, but according to my own abilities. Were I to pay your deserts, I fear I should leave myself poor indeed. Imagine that you have made me a present of the picture, for literally as such I take it, and that I have begged your acceptance of the enclosed trifle. As this is really the case, with how much reason do I subscribe myself,

Your most obliged humble servant,

Charlemont

This elevating circumstance had its contrast, and brought on a train of most dissatisfactory circumstances, which by happening at a time when I thought myself, as it were, landed, and secure from tugging any longer at the oar, were rendered doubly distressing. A gentleman (now a nobleman), seeing this picture,

pressed me with much vehemence to paint another for him, upon the same terms. To this I reluctantly assented; and as I had been frequently flattered for my power of giving expression, I thought the figure of Sigismunda weeping over the heart of her lover, would enable me to display it.[1] Impressed with this idea, I fixed upon this very difficult subject. My object was dramatic, and my aim to draw tears from the spectator; an effect I have often witnessed at a tragedy; and it therefore struck me that it was worth trying, if a painter could not produce the same effect, and touch the heart through the eye, as the player does through the ear. Thus far I have been gratified; I have more than once seen the tear of sympathy trickle down the cheek of a female, while she has been contemplating the picture.

As four hundred pounds had a short time before been bid for a picture of Sigismunda, painted by a French master, but falsely ascribed to Corregio, four hundred pounds was the price at which I rated this.

By any other of my pursuits I could have got twice the sum in the time I devoted to it; nor was it more than half what a fashionable face-painter would have gained in the same period. Upon these grounds I put

1. *Sigismunda Mourning over the Heart of Guiscardo*, 1759, Tate, London, ill. p. 117

it at this sum; see the letter, and see the answer. It ended in my keeping the picture in my painting-room, and his Lordship keeping his money in his pocket. Had it been Charlemont!

*This transaction having given rise to many ridiculous false-hoods, the following unvarnished tale will set the whole in its true light. (January, 1764.)*

*The picture of Sigismunda was painted at the earnest request of Sir Richard Grosvenor, now Lord Grosvenor, in the year 1759, at a time when Mr. Hogarth had fully determined to leave off painting; partly on account of ease and retirement, but more particularly because he had found by thirty years' experience, that his pictures, except in an instance or two mentioned in the note,\* had not produced him one quarter of the profit that arose from his engravings. However, the flattering compliments, as well as generous offers made him by the above gentleman (who was immensely rich), prevailed upon the unwary artist to undertake this difficult subject (which being seen, and fully approved of by his Lordship, whilst in hand), was, after much time and the utmost efforts finished,—BUT HOW! the painter's death (as usual), can only positively determine. The price required for it was therefore*

---

\* The Altar-piece in St. Mary Redcliffe's, Bristol, for which he received £500; and the *Paul before Felix*, painted for Lincoln's Inn Hall, London.

*Sigismunda Mourning over the Heart of Guiscardo, 1759*

*not on account of its value as a picture, but proportioned to the value of the time it took in painting.*

*This nobleman, in the interim, fell into the clutches of the dealers in old pictures; the treatment a man who painted new ones was to expect where these gentry once get a footing, so much alarmed the artist, that he thought it best to set his Lordship at full liberty to take or reject the picture, by writing the following letter, and putting him in mind of the agreement which was made when the work was undertaken.*

<div align="center">

MR. HOGARTH'S LETTER

TO SIR RICHARD GROSVENOR

</div>

<div align="right">

June 13, 1757

</div>

Sir,

I have done all I can to the picture of Sigismunda; you may remember you was [sic] pleased to say you would give me what price I should think fit to set upon any subject I would paint for you, and at the time you made this generous offer, I in return made it my request, that you would use no ceremony in re-fusing the picture when done, if you should not be thoroughly satisfied with it. This you promised should be as I pleased, which I now entreat you to comply with, without the least hesitation, if you think four hundred too much money for it.* One more favour

* N. B. At Sir Luke Schaub's sale. Sir Richard Grosvenor bid £400

I have to beg, which is, that you will determine on this matter as soon as you can conveniently, that I may resolve whether I shall go about another picture, for Mr. Hoare the banker, on the same conditions, or stop here.

I am, &c. W. H.

SIR RICHARD GROSVENOR

TO MR. HOGARTH

Grosvenor square, Sunday morning, June 17th

Sir,

I should sooner have answered yours of the 13th instant, but have been mostly out of town. I understand by it that you have a commission from Mr. Hoare for a picture. If he should have taken a fancy to the Sigismunda, I have no sort of objection to your letting him have it; for I really think the performance so striking and inimitable, that the constantly having it before one's eyes, would be too often occasioning melancholy ideas to arise in one's mind, which a curtain's being drawn before it would not diminish in the least.

I am, Sir, your most obedient servant,

Richard Grosvenor

for a lesser picture, said to be a Corregio, but really painted by an obscure French artist.

## MR. HOGARTH'S REPLY

Sir Richard,

As your obliging answer to my letter in regard to the picture of Sigismunda did not seem to be quite positive, I beg leave to conclude you intend to comply with my request, if I do not hear from you within a week.

I am, &c. W. H.

*His Lordship not thinking fit to take any further notice of the affair, here it must have ended; but things having been represented in favour of his Lordship, and much to Mr. Hogarth's dishonour, the foregoing plain tale is therefore submitted to such as may at any time think it worthwhile to see the whole truth, in what has been so publicly talked of.*

As the most violent and virulent abuse thrown on Sigismunda was from a set of miscreants, with whom I am proud of having been ever at war, I mean the expounders of the mysteries of old pictures, I have been sometimes told they were beneath my notice. This is true of them individually, but as they have access to people of rank, who seem as in happy in being cheated as these *merchants* are in cheating them, they have a power of doing much mischief to a modern

artist. However mean the vender of poisons, the mineral is destructive:—to me its operation was troublesome enough. Ill-nature spread so fast, that now was the time for every little dog in the profession to bark, and revive the old spleen which appeared at the time of the *Analysis*. The anxiety that attends endeavouring to recollect ideas long dormant, and the misfortunes which clung to this transaction, coming at a time when nature demands quiet, and something besides exercise to cheer it, added to my long sedentary life, brought on an illness which continued twelve months. But when I got well enough to ride on horseback, I soon recovered. This being a period when war abroad and contention at home engrossed everyone's mind, prints were thrown into the background; and the stagnation rendered it necessary that I should do some *timed thing*, to recover my lost time, and stop a gap in my income. This drew forth my print of *The Times*, a subject which tended to the restoration of peace and unanimity, and put the opposers of these humane objects in a light, which gave great offence to those who were trying to foment disaffection in the minds of the populace. One of the most notorious among them, till

*Overleaf: The Times (plate 1), 1762. This ferocious satire on the war party of Pitt and his allies (including Wilkes and Churchill in the garret windows) show them fanning the flames or trying to prevent the King from extinguishing the fires*

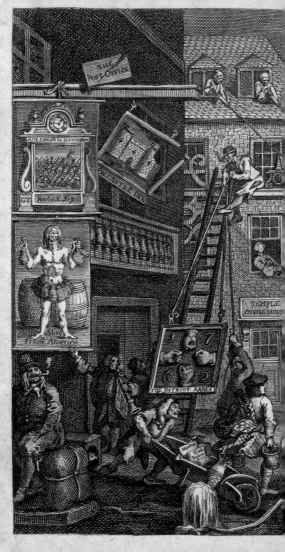

now rather my friend and flatterer [i.e. John Wilkes], attacked me in a North Briton, in so infamous and malign a style, that he himself, when pushed even by his best friends, was driven to so poor an excuse as to say, he was drunk when he wrote it. Being at that time very weak, and in a kind of slow fever, it could not but seize on a feeling mind. My philosophical friends advise me to laugh at the nonsense of party-writing— who would mind it ? but I cannot rest myself—

> Who steals my gold, steals trash;
>                 'tis something; nothing;
> 'Twas mine, 'tis his, and has been slave
>                 to thousands:
> But he that filches from me my good name,
> Robs me of that which not enriches him,
> And makes me poor indeed

Such being my feelings, my great object was to return the compliment, and turn it to some advantage.

This renowned patriot's portrait drawn, like as I could as to features, and marked with some indications of his mind, fully answered my purpose. The ridiculous was apparent to every eye. A Brutus! a saviour of his country, with such an aspect! was so arrant

*Opposite: John Wilkes, 1763*

*John Wilkes Esqr.*

Drawn from the Life and Etch'd in Aquafortis by Wm. Hogarth.

Price 1 Shilling.          Publish'd according to Act of Parliament May ye 16. 1763.

a farce, that though it gave rise to much laughter in the lookers-on, galled both him and his adherents to the bone. This was proved by the papers being every day crammed with invectives against the artist, till the town grew absolutely sick of thus seeing me always at full length.

Churchill, Wilkes's toad-eater, put the North Briton into verse, in an epistle to Hogarth; but as the abuse was precisely the same, except a little poetical heightening, which goes for nothing, it made no impression, but perhaps in some measure effaced or weakened the black strokes of the N. B. However, having an old plate by me, with some parts ready, such as the background and a dog, I began to consider how I could turn so much work laid aside to some account, so patched up a print of Master Churchill in the character of a Bear. The pleasure, and pecuniary advantage, which I derived from these two engravings, together with occasionally riding on horseback, restored me to as much health as can be expected at my time of life.

Thus have I gone through the principal circumstances of a life which, till lately, passed pretty much to my own satisfaction, and, I hope, in no respect injurious to any other man. This I can safely assert, I have

*Opposite: The Bruiser (Satire on Charles Churchill), 1763*

THE BRUISER, C. CHURCHILL (once the Rev.ᵈ) in the Character of a Rußian Hercules, Regaling
   himself after having Kill'd the Monster Caricatura that so sorely Gall'd his Virtuous friend the Heaven born WILKES.
— But he had a *Club* this Dragon to Drub.               Or he had ne'er don't I warrant ye;— — — Dragon of Wantl

Design'd and Engraved by W.ᵐ Hogarth. Price 1.ˢ 6.ᵈ          Publish'd according to Act of Parliament August 1. 1763.

invariably to make those about me tolerably happy, and my greatest enemy cannot say I ever did an intentional injury; though, without ostentation, I could produce many instances of men that have been essentially benefited by me. What may follow, God knows.

FINIS

# REMARKS ON
# VARIOUS PRINTS

WRITTEN BY HOGARTH

EDITED BY JOHN IRELAND

1798

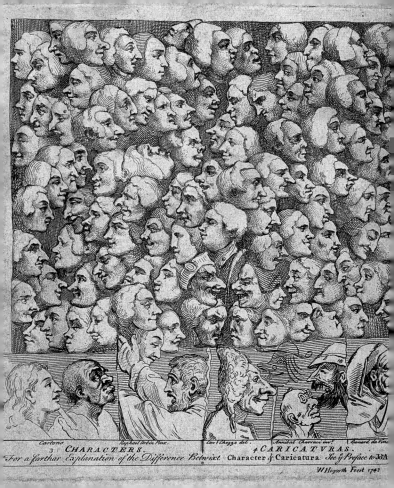

Cartons.          Raphael Urbin Pinx.          Cav.<sup>r</sup> Chegg:s del.          Annibal Charracci inv<sup>t</sup>.          Leonard da Vinc

## CHARACTERS.                    4 CARICATVRAS.

For a farthar Explanation of the Difference Betwixt Character & Caricatura See y<sup>e</sup> Preface to J.<sup>s</sup> A

W Hogarth Fecit 1743.

## CHARACTERS AND CARICATURAS

Being perpetually plagued, from the mistakes made among the illiterate, by the similitude in the sound of the words character and caricatura, I ten years ago endeavoured to explain the distinction by the above print; and as I was then publishing Marriage à-la-Mode, wherein were characters of high life, I introduced the great number of faces there delineated, (none of which are exaggerated) varied at random, to prevent if possible personal application, when the prints should come out:

> We neither this nor that Sir Fopling call.
> He's knight o' th' shire, and represents you all.

This, however, did not prevent a likeness being found for each head, for a general character will always bear some resemblance to a particular one.

## INDUSTRY AND IDLENESS

Industry and Idleness, exemplified in the conduct of two fellow-prentices; where the one, by taking good courses, and pursuing those points for which he was put apprentice, becomes a valuable man, and an

*Opposite: Characters and Caricaturas, 1743*
*Overleaf: Plate 10 of Industry and Idleness, 1747*

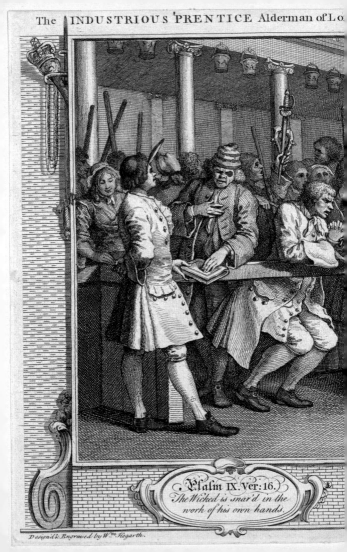

Designd & Engraved by Wm. Hogarth.

Psalm IX. Ver: 16.)
The Wicked is snar'd in the
work of his own hands.

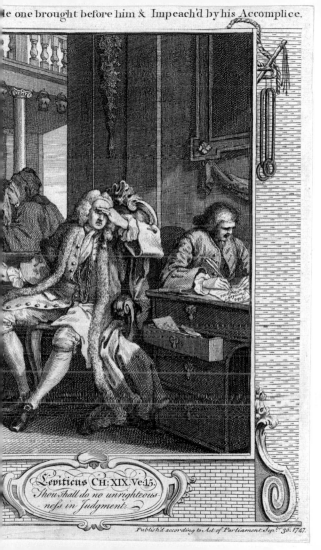

Leviticus CH: XIX. Ve:15,
Thou shall do no unrighteous-
ness in Judgment.

Publish'd according to Act of Parliament Sep.ʳ 30. 1747.

ornament to his country; whilst the other, giving way to idleness, naturally falls into poverty, and most commonly ends fatally, as is expressed in the last print. As these prints were intended more for use than ornament, they were done in a way that might bring them within the purchase of those whom they might most concern; and, lest any part should be mistaken, a description of each print is engraved thereon. Yet, notwithstanding the inaccuracy of the engraving, what was thought conducive and necessary for the purpose for which they were intended, such as action and expression, &c, are as carefully attended to, as the most delicate strokes of the graver would have given, sometimes more; for often expression, the first quality in pictures, suffers in this point, for fear the beauty of the stroke should be spoiled; while the rude and hasty touch, when the fancy is warm, gives a spirit not to be equalled by high finishing.

These twelve prints were calculated for the instruction of young people, and everything addressed to them is fully described in words as well as figures; yet to foreigners a translation of the mottoes, the intention of the story, and some little description of each print, may be necessary. To this may be added, a slight account of our customs, as boys being usually bound for seven years, &c. Suppose the whole story was made

into a kind of tale, describing in episode the nature of a night-cellar, a marrow-bone concert, a Lord Mayor's show, &c. These prints I have found sell much more rapidly at Christmas than at any other season.

## THE GATE OF CALAIS

After the *March to Finchley*, the next print that I engraved, was the *Roast Beef of Old England*;* which took its rise from a visit I paid to France the preceding year. The first time an Englishman goes from Dover to Calais, he must be struck with the different face of things at so little a distance, A farcical pomp of war, pompous parade of religion, and much bustle with very little business. To sum up all, poverty, slavery, and innate insolence, covered with an affection of politeness, give you even here a true picture of the manners of the whole nation; nor are the priests less opposite to those of Dover, than the two shores. The friars are dirty, sleek, and solemn; the soldiery are lean, ragged, and tawdry; and as to the fishwomen — their faces are absolute leather.

* So does he express himself in the MS. though the *Roast Beef* was published March 6, 1749; and the *March*, Dec. 31, 1750.—Note by John Ireland

O The Roast Beef of Old England &c., 1749. Also known as The Gate of Calais, the image commemorates Hogarth's visit to France in 1748

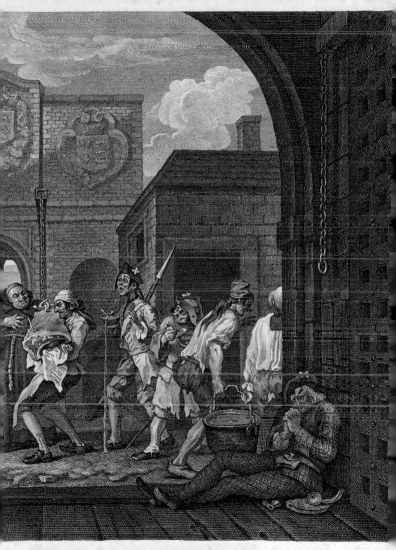

As I was sauntering about, and observing them near the Gate, which it seems was built by the English, when the place was in our possession, I remarked some appearance of the arms of England on the front. By this, and idle curiosity, I was prompted to make a sketch of it, which being observed, I was taken into custody; but not attempting to cancel any of my sketches or memorandums, which were found to be merely those of a painter for his private use, without any relation to fortification, it was not thought necessary to send me back to Paris. I was only closely confined to my own lodgings, till the wind changed for England; where I no sooner arrived, than I set about the picture, made the gate my background, and in one corner introduced my own portrait, which has generally been thought a correct likeness, with the soldier's hand upon my shoulder.* By the fat friar, who stops the lean cook, that is sinking under the weight of a vast sirloin of beef, and two of the military bearing off a great kettle of soup maigre, I meant to display to my own countrymen the striking difference between the food, priests, soldiers, &c, of two nations so contiguous, that in a clear day one coast may be

*This was afterwards copied for a watch-paper.—Note by John Ireland

seen from the other. The melancholy and miserable Highlander, browzing on his scanty fare, consisting of a bit of bread and an onion, is intended for one of the many that fled from this country after the rebellion in 1745.

### BEER STREET AND GIN LANE

When these two prints were designed and engraved, the dreadful consequences of gin-drinking appeared in every street. In *Gin Lane*, every circumstance of its horrid effects is brought to view *in terrorem*. Idleness, poverty, misery, and distress, which drives even to madness and death, are the only objects that are to be seen; and not a house in tolerable condition but the pawnbroker's and Gin-shop.

*Beer Street*, its companion, was given as a contrast, where that invigorating liquor is recommended, in order to drive the other out of vogue. Here all is joyous and thriving. Industry and jollity go hand in hand. In this happy place, the pawnbroker's is the only house going to ruin; and even the small quantity of porter that he can procure is taken in at the wicket, for fear of further distress.

*Overleaf: Gin Lane and Beer Street, both 1751*

# GIN LANE.

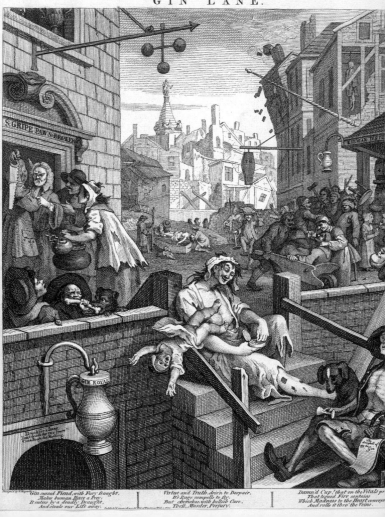

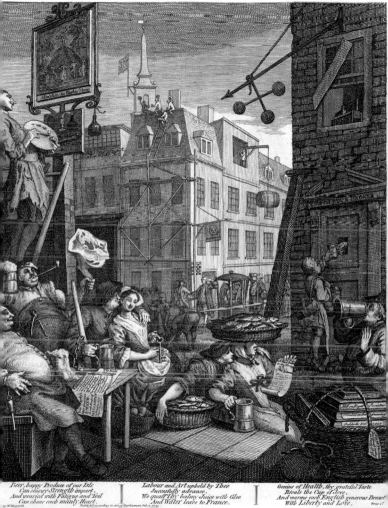

Beer, happy Produce of our Isle
Can sinewy Strength impart,
And wearied with Fatigue and Toil
Can chear each manly Heart.

Labour and Art upheld by Thee
Successfully advance,
We quaff Thy balmy Juice with Glee
And Water leave to France.

Genius of Health, thy grateful Taste
Rivals the Cup of Jove,
And warms each English generous Breast
With Liberty and Love.

WILLIAM HOGARTH

## FOUR STAGES OF CRUELTY

The leading points in these, as well as the two preceding prints, were made as obvious as possible, in the hope that their tendency might be seen by men of the lowest rank. Neither minute accuracy of design, nor fine engraving, were deemed necessary, as the latter would render them too expensive for the persons to whom they were intended to be useful. And the fact is, that the passions may be more forcibly expressed by a strong bold stroke, than by the most delicate engraving. To expressing them as I felt them, I have paid the utmost attention, and as they were addressed to hard hearts, have rather preferred leaving them hard and giving the effect, by a quick touch, to rendering them languid and feeble by fine strokes and soft engraving; which require more care and practice than can often be attained, except by a man of a very quiet turn of mind. Mason, who gave two strokes to every particular hair that he engraved, merited great admiration; but at such admiration I never aspired, neither was I capable of obtaining it if I had.

The prints were engraved with the hope of, in some degree, correcting that barbarous treatment of

*Opposite: First Stage of Cruelty; following pages: Second Stage of Cruelty, and Third Stage of Cruelty: Cruelty in Perfection, all 1751*

# FIRST STAGE OF CRUELTY.

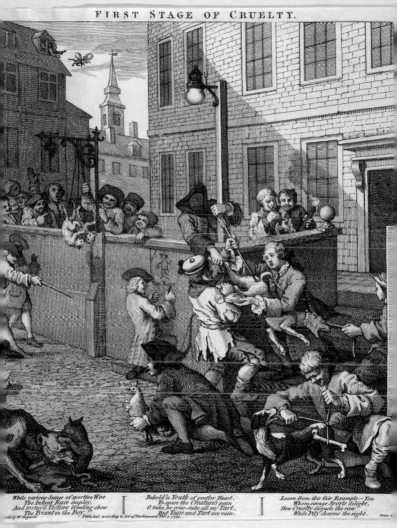

While various Scenes of sportive Woe
The Infant Race employ,
And tortur'd Victims bleeding shew
The Tyrant in the Boy.

Behold! a Youth of gentler Heart,
To spare the Creature's pain
O take, he cries—take all my Tart,
But Tears and Tart are vain.

Learn from this fair Example—You
Whom savage Sports delight,
How Cruelty disgusts the view,
While Pity charms the sight.

I I I

Design'd by W. Hogarth     Publish'd according to Act of Parliament Feb: 1. 1751.     Price 1s

# SECOND STAGE OF CRUELTY.

The generous Steed in hoary Age
  Subdu'd by Labour lies,
And mourns a cruel Master's rage,
  While Nature Strength denies.

The tender Lamb o'er drove and faint,
  Amidst expiring Throng,
Bleats forth its innocent complaint
  And dies beneath the Blows.

Inhuman Wretch! say whence proceeds
  This coward Cruelty?
What Int'rest springs from barb'rous deeds?
  What Joy from Misery?

Design'd by W. Hogarth.        Publish'd according to Act of Parliament Feb. 1. 1751.

# CRUELTY IN PERFECTION.

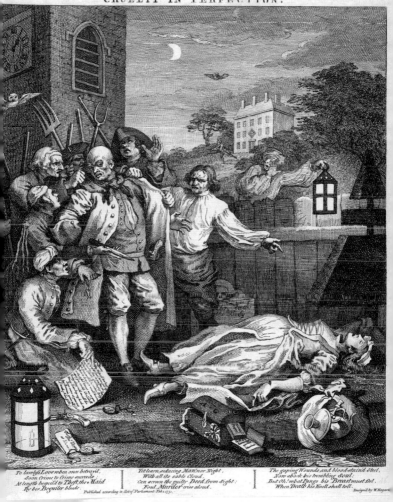

To lawless Love when once betray'd,
Soon Crime to Crime succeeds:
At length beguil'd to Theft, the Maid
By her Beguiler bleeds.

Yet learn, seducing Man! nor Night,
With all its sable Cloud,
Can screen the guilty Deed from Sight;
Foul Murder cries aloud.

The gaping Wounds and blood-stain'd Steel,
Now shock his trembling Soul:
But Oh! what Pangs his Breast must feel,
When Death his Knell shall toll.

Published according to Act of Parliament Feb.1 1751.

Designed by W. Hogarth

# THE REWARD OF CRUELTY.

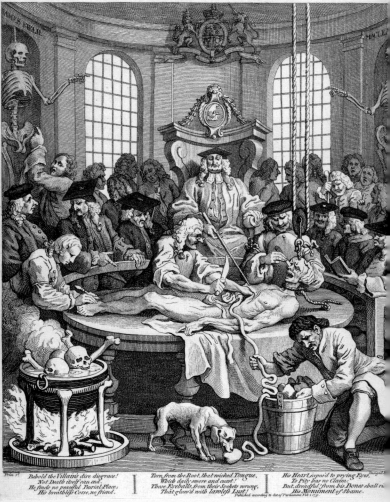

Behold the Villain's dire disgrace!
Not Death itself can end.
He finds no peaceful Burial Place;
His breathless Corse, no friend.

Torn from the Root, that wicked Tongue,
Which daily swore and curst!
Those Eyeballs, from their Sockets wrung,
That glow'd with lawless Lust!

His Heart, expos'd to prying Eyes,
To Pity has no Claim.
But, dreadful! from his Bones shall rise,
His Monument of Shame.

Price 1s

Designd &

Published according to Act of Parliament Feb.1.1751.

animals, the very sight of which renders the streets of our metropolis so distressing to every feeling mind. If they have had this effect, and checked the progress of cruelty, I am more proud of having been the author, than I should be of having painted Raphael's Cartoons.

The French, among their other mistakes respecting our tragedies, &c. &c, assert, that such scenes could not be represented except by a barbarous people. Whatever may be our national character, I trust that our national conduct will be an unanswerable refutation.

### ELECTION ENTERTAINMENT

These two patriots,* who, let what party will prevail, can be no gainers, yet spend their time, which is their fortune, for what they suppose right, and for a glass of gin lose their blood, and sometimes their lives, in support of the cause, are, as far as I can see, entitled to an equal portion of fame with many of the emblazoned heroes of ancient Rome; but such is the effect of prejudice, that though the picture of an antique wrestler is admired as a grand character, we necessarily annex an idea of vulgarity to the portrait of

* The Butcher with *pro patria* in his cap, and his wounded companion.—Note by John Ireland

*Opposite: Fourth Stage of Cruelty: The Reward of Cruelty, 1751*

147

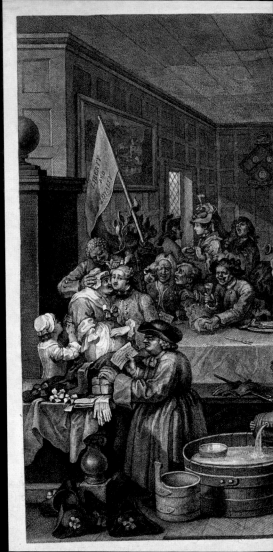

*An Election Entertainment,* 1755

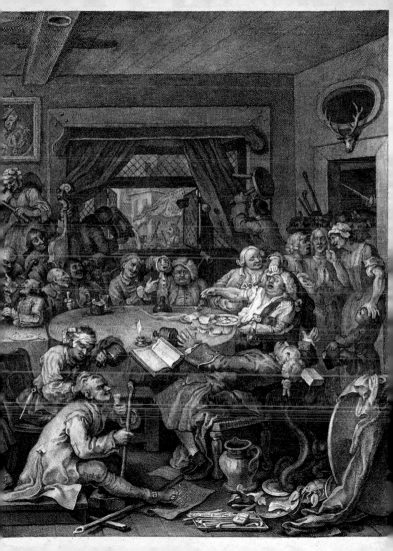

a modern boxer. An old blacksmith in his tattered garb is a coarse and low being; strip him naked, tie his leathern apron round his loins,—chisel out his figure in free-stone or marble, precisely as it appears,—he becomes elevated, and may pass for a philosopher, or a Deity.

## THE BENCH

I have ever considered the knowledge of character, either high or low, to be the most sublime part of the art of painting or sculpture; and caricatura as the lowest: indeed as much so as the wild attempts of children, when they first try to draw:—yet so it is, that the two words, from being similar in sound, are often confounded. When I was once at the house of a foreign face-painter, and looking over a legion of his portraits, Monsieur, with a low bow, told me that he infinitely admired my caricatures! I returned his *congé* and assured him, that I equally admired his.

I have often thought that much of this confusion might be done away, by recurring to the three branches of the drama, and considering the difference between Comedy, Tragedy, and Farce. Dramatic dialogue, which represents nature as it really is, though neither in the most elevated nor yet the most familiar style, may fairly be denominated Comedy:

The Bench, 1758

for every incident introduced might have thus happened, every syllable have been thus spoken, and so acted in common life. Tragedy is made up of more extraordinary events. The language is in a degree inflated, and the action and emphasis heightened. The performer swells his voice, and assumes a consequence in his gait; even his habit is full and ample, to keep it on a par with his deportment. Every feature of his character is so much above common nature, that, were people off the stage to act, speak, and dress in a similar style, they would be thought fit for Bedlam. Yet with all this, if the player does not o'erstep the proper bounds, and, by attempting too much, become swol'n, it is not caricatura, but elevated character. I will go further, and admit that with the drama of Shakespeare, and action of Garrick, it may be a nobler species of entertainment than comedy.

As to Farce, where it is exaggerated, and *outré*, I have no objection to its being called caricatura, for such is the proper title.

### THE FIVE ORDERS OF PERRIWIGS

There is no great difficulty in measuring the length, breadth, or height of any figures, where the parts are

*Opposite: The Five Orders of Perriwigs, 1761*

The five orders of PERRIWIGS as they were worn at the late CORONATION measured Architectonically.

EPISCOPAL

OLD PERRIAN or ALDER MANIC

LEXONIC

COMPOSITE or HALF NATURAL

QUEERINTHIAN or QUEUE de RENARD

A
Corona or Seymour or Fore top.
B
Architrave or Archivolt or Caul?
C
Colarino or Hypotrachilium or Frizz.
D
Triglyph Membr ветla or neckclock.
E
Gutta or Drops or Buckle?.
F
Base or Full Bottom.
G
Asle de Pigeon or Wing.
H
Fillet or Ribbon.
I
Helices or Volute or Spiral or Curl.

ATHENIAN Measuring

Least the Beauty should chiefly depend as usual, on the delicacy of the Author these CAPITELS the Engraving hath Etched the them with his own hand.

Advertisment.

In about Seventeen Years will be compleated, in Six Volumns, folio, price, Fifteen Guineas, the exact measurements of the PERRIWIGS of the ancients; taken from the Statues, Bustos & Basso-Relievos, of Athens, Palmira, Balbec, and Rome, by MODESTO Perriwig-meter from Lagado.

N.B. None will be Sold but to Subscribers._____ Publish'd as the Act directs Oct.º 15.1761 by W.ᵐ Hogarth.

made up of plain lines. It requires no more skill to take the dimensions of a pillar or cornice, than to measure a square box, and yet the man who does the latter is neglected, and he who accomplishes the former, is considered as a miracle of genius; but I suppose he receives his honours for the distance he has travelled to do his business.*

*This is a pointed ridicule of Stuart's *Antiquities of Athens*, in which the measurements of all the members of the Greek architecture are given with minute accuracy.—Note by John Ireland

# REMARKS ON
# MARRIAGE A-LA-MODE

WRITTEN BY HOGARTH

EDITED BY JOHN IRELAND

WITH FURTHER EXPLANATIONS
BY THOMAS CLERK

1812

*Hogarth's remarks on Marriage A-la-Mode were origi-*
*nally collected by John Ireland and published in later*
*editions of his* Hogarth Illustrated *(along with the*
*'Anecdotes' and the 'Remarks on Various Prints' repro-*
*duced earlier in this volume). They were republished*
*in 1812 in* Hogarth's Works, *a volume edited by*
*Thomas Clerk, who added some further explanations,*
*in part based on the commentary by the Rev. (or Dr.)*
*John Trusler, an associate of Hogarth's wife, Jane.*
*Hogarth's text is shown in roman type, and Clerk's re-*
*marks in italics, together with his introduction, opposite,*
*which explains the origins of the text.*

*The causes of unhappy marriages have furnished employment for the reflecting philosopher, the fancy of the novelist, and the imagination of the poet. It was reserved for the pencil of Hogarth to embody their ideas, to reprobate the absurdity and folly of forming matrimonial connections chiefly for pecuniary considerations: and as this practice is most prevalent in the higher circles, he has taken the subject of Marriage A-la-Mode from high life; and, it must be acknowledged, has treated it in his happiest manner. These plates were published in the year 1745; and the pictures were afterwards (in 1750) disposed of by a kind of private auction, not carried on by personal bidding, but by a written ticket, on which everyone was to put the price he would give, with his name subscribed thereto. The successful purchaser was the late Mr. Lane (of Hillingdon), who communicated the particulars of this singular transcription to Mr. Nichols: the following descriptions were found among Mr. L.'s papers after his decease, and his family believe them to be* Hogarth's explanations, *either copied from the artist's own* handwriting, *or verbally given to Mr. Lane at the time he purchased the pictures. That the descriptions in question are Hogarth's is highly probable; as, on comparing them with the explanations published in French by Roucquet (to whom the painter is* known *to have communicated information), there is a very striking coincidence. We therefore subjoin the artist's own account of his pictures, with the addition, however, of such supplemental facts and remarks as either suggested themselves, or could be obtained after minute investigation.*

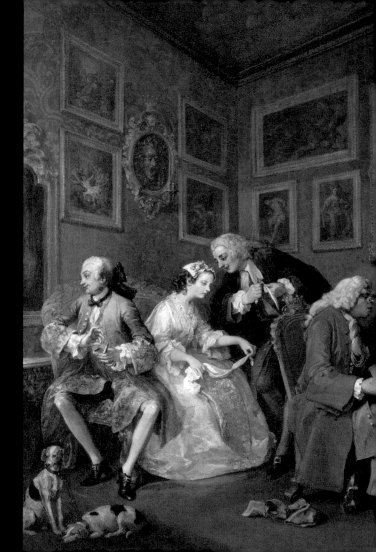

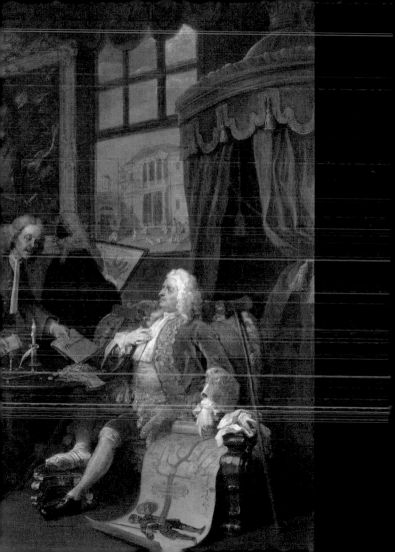

WILLIAM HOGARTH

## I. THE MARRIAGE SETTLEMENT

There is always a something wanting to make men happy.—The great think themselves not sufficiently rich, and the rich believe themselves not enough distinguished. This is the case of the alderman of London, and the motive which makes him covet for his daughter the alliance of a great Lord; who, on his part, does not consent thereto but on condition of enriching his son; and this is what the painter calls *Marriage A-la-Mode.*

These sort of marriages are truly but too common in England, and it is moreover not unfrequent to see them unhappy as they are ill chosen. The two figures of the Alderman and the Earl are in every respect so well *characterized* that they explain themselves. The Alderman,* with an air of business, counts his money like a man used to this employment; and the Earl, full of his titles and the greatness of his birth, which he lets you see goes as high as William the Conqueror, is in an attitude which shews him full of pride; you think you hear him say, ME, MY Arms, MY Titles, MY

* Roucquet calls him a sheriff (*échevin*), and such in fact he is, as is obvious from the gold chain hanging from his neck.—Note by Thomas Clerk

Family, MY Ancestors:— everything about him carries marks of distinction; his very crutches, the humbling consequence of his infirmities, are decked with an earl's coronet; these infirmities are introduced here as the usual consequence of that irregularity of living but too frequent among the great. The two persons who are betrothed, on their parts are by no means attentive to one another. The one looks at himself in the glass, is taking snuff, and thinking of nothing: the other is playing negligently with a ring, and seems to hear with indifference the conversation of a kind of a lawyer (counsellor Silver-tongue) who attends the execution of the marriage articles. Another lawyer is exclaiming with admiration on the beauty of a building seen at a distance, and upon which the Earl has spent his whole fortune, and has not sufficient to finish the same. A number of idle footmen, who are about the court of this building, finish the representation of the ruinous pageantry in which the Earl is engaged.

*The furniture of the apartment is in unison with the proud character of the peer, whose coronet may frequently be observed. The cumbrous ornaments of the ceiling (delineating the destruction of Pharaoh and his host in the Red Sea) are supposed to be intended as a ridicule of false taste; the pompous picture on the left of the window is also designed as a banter upon the preposterous*

*style of the French portrait painters. This ancestor of our peer is decorated with the insignia of several foreign orders: at the top of one corner of the painting, two winds are blowing across each other, while the hero's drapery flies in contrary directions. A comet is passing with a stream of light over his head: in his left-hand he grasps the thunderbolts of Jupiter; and, with a mingled smile of self-complacency and pertness, he is sitting on a cannon just discharged, the ball of which, absurdly enough, is still visible.*

*The subjects of the other pictures are,* David killing Goliah,—Prometheus and the Vulture,—the Murder of the Innocents,—Judith and Holofernes,—St Sebastian shot full of Arrows,—Cain destroying Abel, *and* the Martyrdom of St Lawrence on the Gridiron.

*"Among such little circumstances as might escape the notice of a careless spectator," (Mr Nichols observes\*), "is the thief in the candle, emblematical of the mortgage on his lordship's estate."† He further remarks, that the unfinished "edifice seems at a stand for want of money, no workmen appearing on the scaffolds or near them."*

*In order to keep up the humour of the scene, Hogarth has introduced two pointers (in the left-hand corner, near the intended bride and bridegroom), chained together against their will, as*

---

\* Nichols, *Hogarth*, vol. II, p. 181.

† 'Thief in a candle: Part of the wick or snuff, which falling on the tallow, burns and melts it, and causing it to gutter, thus steals it away.' Grose's *Dictionary*, 1811

*fitly emblematic of the nuptial ceremony which is about to be performed.—One of the dogs that is lying down, has a coronet stamped on its side.*

*All the characters are admirably drawn.*

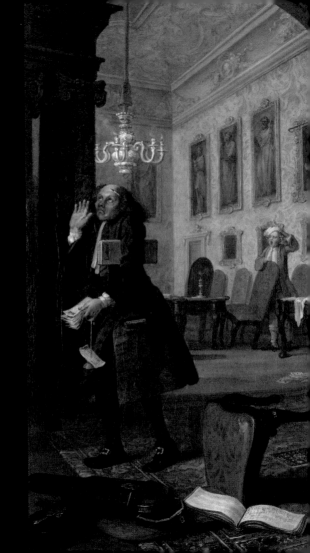

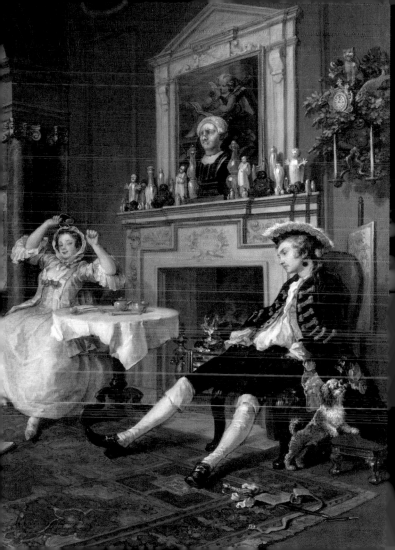

## II. THE TETE-A-TETE

That indifference between the parties which preceded Marriage A-la-Mode has not been wanting to follow it. We unite ourselves by contract, and we live separately by inclination. Tired and fatigued one of another, such husbands and wives have nothing in common but a house, tiresome to the husband, and into which he enters as late as he can; and which would not be less tiresome to the lady, was it not sometimes the theatre of other pleasures, either in entertainments or routs. There is here represented a room where there has just been one of these routs, and the company just separated, as you see by the wax-candles not yet extinguished. The clock shows you it is noon; and this anticipation of the night upon the day, is not the slightest of those strokes which are intended to show the disorder which reigns in the house. Madam, who has just had her tea, is in an attitude which explains itself, perhaps, too much. Be that as it will, the painter's intention is to represent this lady neglected by her husband, under dispositions which make a perfect contrast with the present situation of this husband, who is just come home, and who appears in a state of the most perfect indifference, fatigued, exhausted, and glutted with pleasure. This figure of the husband,

by the novelty of its turn, the delicacy and truth of its expression, is most happily executed. A steward of an old stamp, one of those, if such there be, who are contented with their salary, seizes this moment, not being able to find another, to settle some accounts. The disorder which he perceives gives him a motion which expresses his chagrin, and his fear for the speedy ruin of his master.

*The cards scattered on the floor, the treatise of* Hoyle *lying at our heroine's feet, the music and musical instruments thrown down, are strongly characteristic of her dissipated habits; she is yawning with ennui, while the fatigued and disordered appearance of her husband evidently shews that he has not been much better employed. The nature of his nocturnal pursuits is sufficiently marked by his broken sword, and also by the female cap hanging out of his pocket, whence it is on the point of being drawn by a playful lap-dog. It is worthy of note, that Hogarth has humorously put into the steward's hands a number of unpaid bills, and placed upon the file only one receipt! The servant in the background seems utterly inattentive to his lord and lady, and to take no notice whatever of the chair on his right, which is in danger of taking fire from the blaze of an expiring taper.*

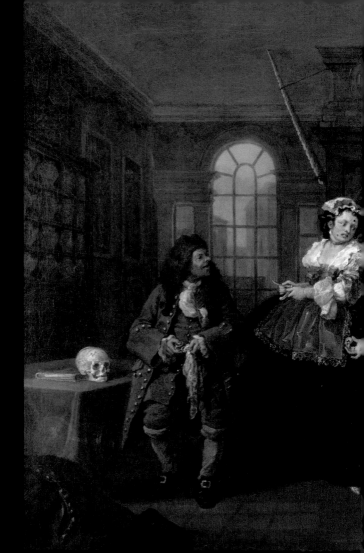

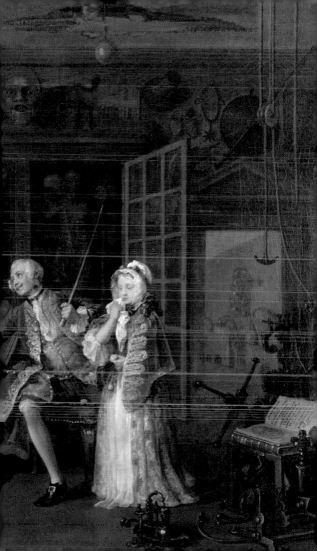

## III. THE INSPECTION

The bad conduct of the hero of the piece must be shewn here; the painter for this purpose introduces him into the apartment of a quack, where he would not have been but for his debauchery. He makes him meet at the same time, at this quack's, one of those women, who, being ruined themselves long since, make afterwards the ruin of others their occupation. A quarrel is supposed to have arisen between this woman and our hero, and the subject thereof appears to be the bad condition, in point of health, of a young girl, from a commerce with whom he had received an injury. This poor girl makes here a contrast on account of her age, her fearfulness, her softness, with the character of the other woman, who appears a composition of rage, madness, and of all other crimes which usually accompany these abandoned women towards those of their own sex. The doctor and his apartments are objects thrown in by way of episode. Although heretofore only a barber, he is now, if you judge by the appearance he makes, not only a surgeon, but a naturalist, a chemist, a mechanic, a physician, and an apothecary; and, to heighten the ridicule, you see he is a Frenchman. The painter, to finish this character according to his own idea, makes him the inventor of

machines extremely complicated, for the most simple operations, as, one to reduce a dislocated limb, and another to draw the cork out of a bottle.

*This circumstance of the barber surgeon seems to be implied by the broken comb, pewter basin, and the horn so placed as to resemble a barber's pole, all which are exhibited either above or within the glass-case; in which the skeleton appears whispering a man who had been exsiccated by some mode of embalming at present unknown. About the time of publishing this set of prints, a number of bodies thus preserved were discovered in a vault in Whitechapel church. Our quack is likewise a virtuoso. An antique spur, a high-crowned hat, old shoes, &c. together with a model of the gallows, are among his rarities. On his table lies a skull, rendered carious by the disease he professes to cure.\* The following verses from Dr. Garth's Dispensary so exactly characterize the motley collection of this nostrum-vender, that*

---

\* Nichols' *Hogarth*, vol. II, p. 179. The initials on the breast of the procuress have been variously interpreted. B. (or E.) C. for the celebrated Betsey Careless (who, after a routine of dissipation, fell a victim to debauchery, and was buried from the poor-house of St Paul's, Covent-Garden); or F. C. for Fanny Cock, daughter of an eminent auctioneer of that day, with whom the artist had some dispute (ibid). Mr. Ireland, however, thinks it probable that these gunpowder initials are merely the mark of a woman of the lowest rank and most infamous description.—Note by Thomas Clerk

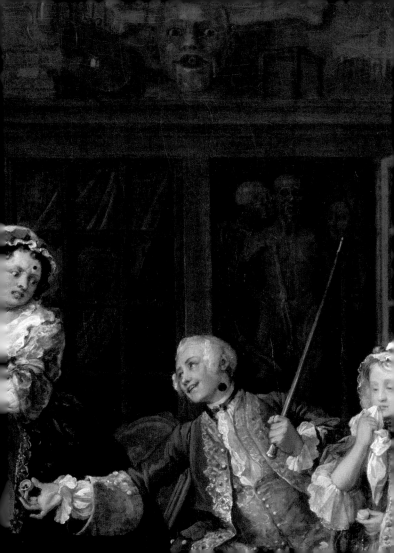

*one might conjecture that Hogarth had copied the description when designing the print:—*

> *His shop the gazing vulgar's eyes employs*
> *With vulgar trinkets, and domestic toys.*
> *Here mummies lay, most reverendly stale;*
> *And there the tortoise hung her coat of mail:*
> *Not far from some huge shark's devouring head,*
> *The flying fish their finny pinions spread.*
> *Aloft in rows large poppy heads were strung.*
> *And near a scaly alligator hung:*
> *In this place drugs, in musty heaps decay'd;*
> *In that, dry'd bladders and drawn teeth were laid.*
>
> Dispensary, *Canto II*\*

\* Sir Samuel Garth (1661-1719), physician to George I. *The Dispensary* was published in 1699.

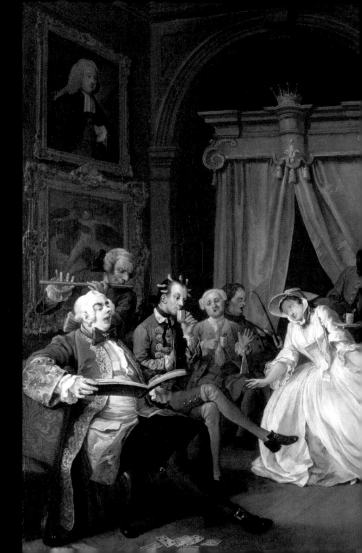

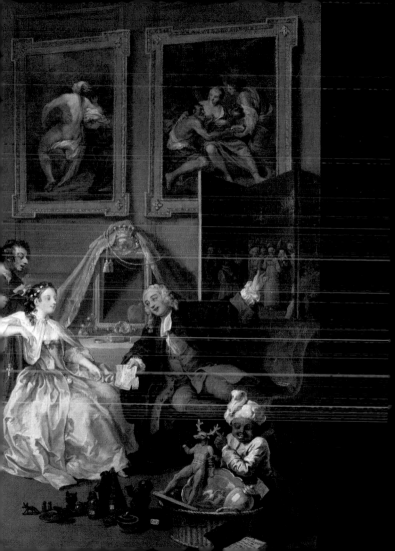

## IV. THE TOILETTE

*The old earl having paid the debt of nature, the young viscount is come into the entire possession of his estate and title; and his dissipated wife has attained the acme of her wishes, in acquiring the rank and appellation of a countess. In consequence of this they mutually launch into every species of fashionable extravagance and folly.*

This piece is amusing by the variety of characters therein represented. Let us begin with the principal; and this is Madam at her toilet: a French valet-de-chambre is putting the finishing stroke to her dress. The painter supposes her returned from one of those auctions of old goods, pictures, and an hundred other things, which are so common at London, and where numbers of people of condition are duped. It is there that, for emulation, and only not to give place to another in point of expence, a woman buys at a great price an ugly pagod, without taste, without worth, and which she has no sort of occasion for. It is there also that an opportunity is found of conversing, without scandal, with people who you cannot see anywhere else. The things which you see on the floor, are the valuable acquisitions our heroine has just made at one of those auctions. It is extremely fashionable

at London to have at your house one of those melo-
dious animals which are brought from Italy at great
expence; there appears one here, whose figure suffi-
ciently distinguishes him to those who have once seen
one of those unhappy victims of the rage of Italians
for music.* The woman there is charmed, almost to
fainting, with the ravishing voice of this singer; but
the rest of the company do not seem so sensible of
it. The country gentleman, fatigued at a stag or fox
chace, is fallen asleep. You see there, with his hair in
papers, one of those personages who pass their whole
life in endeavouring to please, but without succeed-
ing; and there, with a fan in his hand, you see one of
those heretics in love, a disciple of Anacreon. You see
likewise, on the couch, the lawyer, who is introduced
in the first picture, talking to the lady. He appears to
have taken advantage of the indifference of the hus-
band, and that his affairs are pretty far advanced since
the first scene. He is proposing the masquerade to his
mistress, who does not fail to accept of it.

*The insidious counsellor Silver-tongue is pointing to certain
figures on the screen (a friar and a nun in close conversation),*

---

* I.e. a *castrato*. The lack of testosterone encouraged greater length
in the limbs and an expanded ribcage.

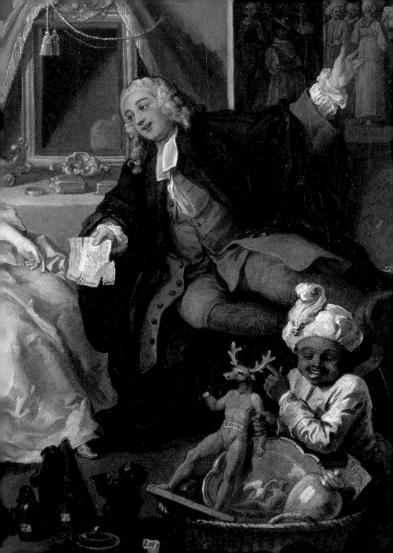

*that sufficiently indicate* his *intentions towards her. A number of complimental message cards lie strewed upon the floor to the following purport:*

Lady Squander's company is desired at
Lady Townley's Drum, next Monday.

Lady Squander's company is desired at
Lady Heathen's Drum-Major, next Sunday.

Lady Squander's company is desired at
Miss Hairbrain's Rout.

Count Basset desire to *no* how Lady Squander
sleep last nite.

*The furniture of the apartment is characteristic of its dissipated tenants. Among the pictures we recognise the portrait of the young barrister;* Jupiter and Io; Ganymede and the Eagle; Lot and his Daughters. *Before we conclude the description of this plate, it is worthwhile to notice the* precious trumpery, *which, from the catalogue on the floor, appears to have been purchased by her Ladyship from the collection of* Sir Thomas Babyhouse. *Among these is a porcelain figure of* Actæon, *to whose horns the little black page is archly pointing (with a sarcastic leer upon his Lady), as emblematical of the ridiculous appearance of his master.*

WILLIAM HOGARTH

## V. THE BAGNIO

*The fatal consequences of going to the masquerade are here sh-*
*ewn to perfection. The ticket was accepted to favour an assigna-*
*tion; the assignation took place, and the catastrophe is dire. The*
*barrister and countess are supposed to have withdrawn to some*
*bagnio, in order to gratify their illicit amours.*

A husband, whose wife goes to the masquerade
without him, is not without his inquietudes; it is natu-
ral that ours here has secretly followed his wife thither,
and from thence to the bagnio, where he finds her
in bed with the lawyer. They fight;—the husband is
mortally wounded: his wife, upon her knees, is making
useless protestations of her remorse. The watchmen
enter;—and the lawyer, in his shirt, is getting out of
the window.

*The* sleek rotundity *of the constable is well contrasted*
*by the lank-visaged guardian of the night; terror and conscious*
*guilt are strongly marked on the countenance of the retreating*
*adulterer. The pallid face of the wounded peer evidently indi-*
*cates the rapid approach of death.*

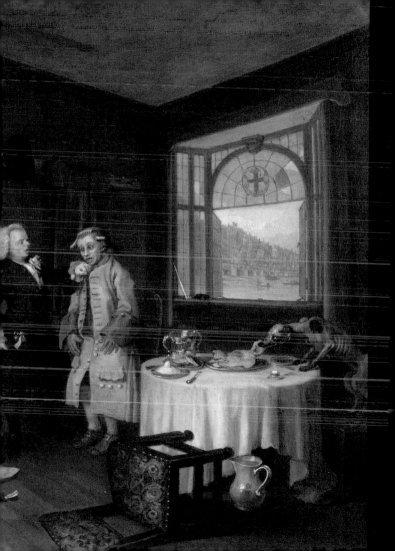

## VI. THE LADY'S DEATH

We are now at the house of the alderman. London Bridge, which is seen through the window, shews the quarter where the people of business live. The furniture of this house does not contribute to its ornament;—everything shews niggardliness: and the dinner, which is on the table, the highest frugality. You see the tobacco pipes set by in the corner: this too is a mark of great economy. Some pictures you see, upon very low subjects, to give you to understand by this choice, that persons who, like the alderman, pass their whole life in thinking of nothing but enriching themselves, generally want taste and elegance; besides, everything here is contrasted with what you saw at the Earl's; the pride of one, and the sordidness of the other, are always equally ridiculous, by the odd subjects of the pictures which are there seen: but generally in the choice of pictures neither the analogy, taste, or agreement one with another are consulted. The broker only is advised with, who, on his part, consults only his own interest, of which he is much more capable of being a judge than he is of painting; like a seller of old books, who knows how to say, here is an Elzevir Horace, or one of the Louvre edition;— and who knows all this, without being acquainted

with poetry, or capable of distinguishing an epigram from an epic poem. There is only one difference between a bookseller and a broker; the first has certain marks by which he knows the edition, and the other is obliged to have recourse to inspiration, which is the only way whereby he is able to judge infallibly, as he does, whether a picture is an original or no. But to return to our subject. The daughter of the alderman, now a widow, is returned to her father. Her lover has been taken and hanged for the murder of her husband: this she has learned from the dying speech, which is at her foot upon the floor. A conscience disturbed and tormented with remorse is very soon drove to despair. This woman, who by the consequence of her infidelity has destroyed her husband, her lover, her reputation, and her quiet, has nothing to lose but her life; this she does by taking laudanum.—She dies. An old servant in tears makes her kiss her child, the melancholy production of an unfortunate marriage. The alderman, more sensible of the least acquisition than of the most tragical events, takes, without emotion, a ring from the finger of his expiring daughter. The apothecary is severely reprimanding the ridiculous footman of the house who had procured the poison, the effects of which finish the catastrophe.

*Thus ends this strange eventful history.*

*Lord Orford has the following just observations on the series of prints which form the subject of Marriage A-la-Mode.—"An intrigue is carried on throughout the piece. He (Hogarth) is more true to character than Congreve; each personage is distinct from the rest, acts in his sphere, and cannot be confounded with any other of the dramatis personæ. The alderman's foot-boy, in the last print, is an ignorant rustic; and if wit is struck out from the characters in which it is not expected, it is from their acting conformably to their situation, and from the mode of their passions, and* not *from their having the wit of fine gentlemen. Thus, there is wit in the figure of the alderman, who, when his daughter is expiring in the agonies of poison, wears a face of so-licitude—but it is to save her gold ring, which he is gently draw-ing from her finger. The thought is parallel to Molière's, where the miser puts out one of the candles as he is talking. Molière, inimitable as he has proved, brought a rude theatre to perfection. Hogarth had no model to follow and improve upon."** 

---

* Horace Walpole, 4th Earl of Orford, "Anecdotes of Painting", in *Works*, vol. III, p. 453.

## List of illustrations

p. 66: *Boys peeping at Nature*, 1751, etching and engraving, 15 x 12.3 cm (sheet),
Metropolitan Museum of Art, New York

pp. 80-81: *Analysis of Beauty*, plate 1, 1753, etching and engraving,
39 x 50.5 cm (plate), Metropolitan Museum of Art, New York

p. 91 *Time Smoking a Picture*, c. 1761, etching and aquatint, 24 x 18 cm (sheet),
Metropolitan Museum of Art, New York

p. 96 *Self-portrait with his pug, Trump*, 1745, oil on canvas, 90 x 70 cm,
Tate, London

p. 108 *Self-portrait*, c. 1757-58, oil on canvas, 45.1 x 42.5 cm,
National Portrait Gallery, London

pp. 112-13 *The Lady's Last Stake*, 1759, oil on canvas, 91 x 105 cm,
Albright-Knox Art Gallery, Buffalo, NY

p. 117 *Sigismunda Mourning over the Heart of Guiscardo*, 1759, oil on canvas,
100 x 127 cm, Tate, London

pp. 122-23 *The Times*, plate 1, 1762, etching and engraving, 24.5 x 30.3 cm
(sheet), Metropolitan Museum of Art, New York

p. 125 *John Wilkes*, 1763, etching and engraving, 36.4 x 23.4 cm (sheet,
trimmed within plate), Metropolitan Museum of Art, New York

p. 127 *The Bruiser (Satire on Charles Churchill)*, 1763, etching and engraving,
37.7 x 27 cm (sheet), Metropolitan Museum of Art, New York

p. 130 *Characters and Caricaturas*, 1743, etching and engraving, 23.4 x 20.9 cm
(plate), Wellcome Collection, London

pp. 132-33 *Industry and Idleness*, plate 10, 1747, etching and engraving,
25.8 x 34.8 cm (sheet), Metropolitan Museum of Art, New York

pp. 136-37 *O the Roast Beef of Old England &c.*, 1749, etching and engraving,
38.2 x 46 cm (sheet), Metropolitan Museum of Art, New York

p. 140 *Gin Lane*, 1751, etching and engraving, 38.3 x 31.7 cm (sheet),
Metropolitan Museum of Art, New York

p. 141 *Beer Street*, 1751, etching and engraving, 42 x 34.4 cm (sheet),
Metropolitan Museum of Art, New York

pp. 143-46 *The Four Stages of Cruelty*, 1751, etching and engraving,
each plate 35.5 x 29.9 cm, Metropolitan Museum of Art, New York

pp. 148-49 *An Election Entertainment*, 1755, etching and engraving,
40.3 x 54.1 cm (sheet), Metropolitan Museum of Art, New York

p. 151 *The Bench*, 1758, etching and engraving, 30.5 x 21.2 cm (sheet),
Metropolitan Museum of Art, New York

Illustrations pp. 1, 16-17, 96, 158-59, 163, 164-65, 168-69, 172, 174-75, 178, 180-81, 183 and 184-85 Wikimedia; pp. 2, 48-49 Gallerix; on pp. 4, 12, 22-23, 40, 66, 80-81, 91, 117, 122-23, 125, 127, 132-33, 136-37, 140, 141, 143-46, 148-49, 151 and 153 Metropolitan Museum of Art, New York; pp. 6, 8 and 26 Yale Center for British Art, New Haven; p. 14 and 20 Victoria & Albert Museum, London; p. 37 Royal Collection, United Kingdom; pp. 60, 62-63 and 108 Google Arts & Culture; pp. 114-19 Albright-Knox Art Gallery; p. 117 Tate; and p. 130 Wellcome Collection

© 2020 Pallas Athene (Publishers) Ltd.

**Published in the United States of America in 2020 by the J. Paul Getty Museum, Los Angeles**
Getty Publications
1200 Getty Center Drive, Suite 500
Los Angeles, California 90049-1682
getty.edu/publications

Distributed in the United States and Canada by the University of Chicago Press

Printed in China

ISBN 978-1-60606-644-7

Library of Congress Control Number: 2019947834

Published in the United Kingdom by Pallas Athene (Publishers) Ltd.
Studio 11A, Archway Studios
25–27 Bickerton Road, London N19 5JT

Alexander Fyjis-Walker, *Series Editor*
Patrick Davies, *Editorial Assistant*
*Special thanks to* Rachel Barth

Front cover: William Hogarth, *Self-Portrait* (detail), ca. 1735. Oil on canvas, 54.6 x 50.8 cm (21½ x 20 in.). Yale Center for British Art, Paul Mellon Collection